D1156352

The Eighteenth Century

Other titles in the series

To John Russell
in affectionate regard
and fulfilment of an old promise

The Eighteenth Century

STEPHEN JONES

The right of the
University of Cambridge
to print and sell
all manner of books
was granted by
Henry VIII in 1534.
The University has printed
and published continuously
since 1584.

CAMBRIDGE UNIVERSITY PRESS
Cambridge
London New York New Rochelle
Melbourne Sydney

Copn
N
6420
. J66
1985
c. 1

Published by the Press Syndicate of the University of Cambridge
The Pitt Building, Trumpington Street, Cambridge CB2 1RP
32 East 57th Street, New York, NY 10022, USA
10 Stamford Road, Oakleigh, Melbourne 3166, Australia

© Cambridge University Press 1985

First published 1985

Printed in Hong Kong by Wing King Tong

Library of Congress catalogue card number: 83–24057

British Library cataloguing in publication data

Jones, Stephen

The eighteenth century – (Cambridge
introduction to the history of art; 5)
1. Art, Modern–18th century
I. Title
709'03'4 N6447

ISBN 0 521 24003 4 hardcovers
ISBN 0 521 28396 5 paperback

Cooper Union Library

Eta

OCT 2 8 1986

Contents

Contents

Acknowledgements

For permission to reproduce illustrations the author and publisher wish to thank the institutions mentioned in the captions. The following are also gratefully acknowledged:

p 1 Norfolk Museums Service (Norwich Castle Museum); pp 3, 59 Lauros-Giraudon; pp 4, 6, 27, 28, 38 right, 46, 62, 63 A. F. Kersting; p 5 Roger Viollet; pp 8, 9 reproduced by gracious permission of Her Majesty the Queen; pp 12, 13, 14, 75, 80 Musées Nationaux, Paris; pp 16, 38 left, 39 Giraudon; pp 17, 24, 53, 57 The Trustees, The National Gallery, London; pp 18, 21 The Trustees of the Wallace Collection; pp 20, 23, 41, 44, 45, 64, 68 The Trustees of the Victoria and Albert Museum; pp 29, 30 Bildarchiv Foto Marburg; pp 32, 47 (J. P. Neale *Views of the Seats of Noblemen*, vol. V, *c.* 1817) The Syndics of Cambridge University Library; p 33 left The British Library; p 33 right The Greater London Council as Trustees of the Iveagh Bequest, Kenwood; pp 34, 66 Bibliothèque Nationale, Paris; pp 35, 36, 43 The British Architectural Library, RIBA, London; p 37 The Trustees of Sir John Soane's Museum; p 42 Royal Commission on Historical Monuments (England); pp 48, 61 bottom Country Life; p 50 Archivi Alinari; pp 52, 60 Henry E. Huntington Library and Art Gallery, San Marino; p 55 Bildarchiv Preussischer Kulturbesitz; p 58 Oxfordshire County Libraries; p 65 The Fotomas Index; p 67 right reproduced by permission of The Chatsworth Settlement Trustees; p 69 The Director, Wiltshire Library and Museum Service; p 71 top GLC Map and Print Collections; p 71 bottom Guildhall Library, City of London; p 72 Reece Winstone; p 73 French Government Tourist Office; p 77 Crown Copyright Science Museum, London.

1 The world and its taste

Henry Walton, *Sir Robert and Lady Buxton and their Daughter*, *Anne*, 1792, oil on canvas, 73.7 × 92.7 cm, Castle Museum, Norwich.

Eighteenth-century men and women inevitably seem far removed from us, seated stiffly in portraits, constricted by their clothes, the men weighed down with tricorn hats and embroidered waistcoats, the women perched in pannier skirts and encased in whale-bone corsets. Beyond these incidentals of dress and manner, however, there are similarities to our own age. They are curiously close in spirit to the modern world, less inhibited by elaborate sexual and social taboos than any society until the modern age of atheism.

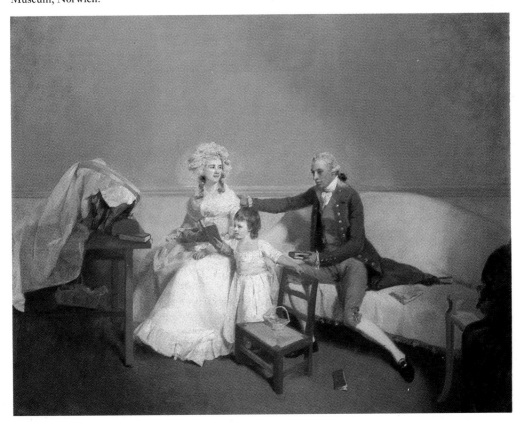

The absence of inhibitions makes them frank and funny about the realities of everyday life, often bawdy, hardly ever shocked.

The flavour of eighteenth-century opinion and the detail of its social life have come down to us in the form of letters and memoirs, chiefly of the leisured and monied, men like Horace Walpole, the youngest son of Britain's great Prime Minister, or the Duc de Saint Simon, an aristocrat at the court of France. Lord Hervey, Lord Chamberlain to George II, has performed the same service for the British court, in frank and mercilessly perceptive records of the royal family of Hanover. This spirit of sophisticated and unprudish acceptance of humanity inhabits many works of art of the age.

The novel, for example, was an art form widely exploited in the eighteenth century. Samuel Richardson, in his books *Pamela* and *Clarissa*, examines the female mind sensitively without recourse to patronising stereotypes. The immediate success of these books in Britain and France shows how Richardson touched on an important and sensitive theme of the age: the development of a modern attitude towards the individual in the context of society.

Women artists, for example, during the eighteenth century were more widely recognised and accepted for their professional talents: Angelica Kauffman in England and Madame Vigée le Brun in France. There was scope for female qualities and an opportunity for the civilised amenities of social and intellectual intercourse. Something of the refinement of this society is mirrored in the delicacy of Rococo painting and architecture. Its intellectual distinction and eager spirit of enquiry is to be found in the development of a Neoclassical style; its roots however are in the seventeenth century.

Louis XIV, who died in 1715, had done more than any other man of the age to shape the political map of western Europe. He built a system of alliances with France as the moderating and leading power. Within France he had set an example of complete royal authority which other kings envied. Important though all this was, the influence of France was even deeper in other things. The fashions, the manners, the whole elegant culture of eighteenth-century life among the upper classes reflected the example of Versailles and Paris. French became the international language of polite soci-

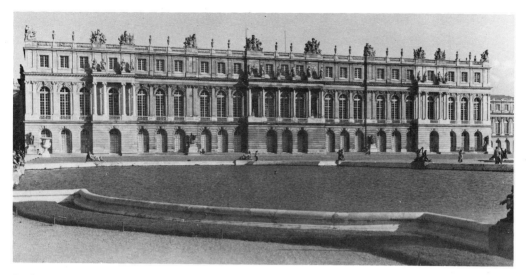

Louis Le Vau & Jules Hardouin-Mansart, Versailles, garden front 1669–85.

ety. The Sun King may not have planned this, but he stamped an image on the future of Europe. The most potent symbol of late-seventeenth-century Europe, in society and in art, had been the palace of Versailles. Its vast imperious mass is an assertion in stone of a political system. The architecture is formal and impressive in scale. It is classical in that it incorporates elements of ancient Greek and Roman architecture.

A little less than one hundred years after the creation of the palace, Ange-Jacques Gabriel built in the park at Versailles a small pavilion-like house for Madame de Pompadour, mistress of Louis XV. The Petit Trianon, built between 1762 and 1768, is also classical, though its style is more usually called 'Neoclassical', to indicate the conscious attempt on the part of the architect to recapture the nobility and simplicity of great Roman architecture. But this building serves as the visible realisation of far more than Roman austerity. It is intimate, designed to allow its owners to escape from the stifling rituals of the court. The pleasing simplicity of the facade is echoed in the decoration of the salon, where moderation in the decorative detailing and furniture creates an overall impression of space and light. There is a strong sense of individuality about this design, in contrast to the impersonal glories of the state rooms of the palace. It is a contrast almost too easy to draw. Versailles was intended to fulfil the necessities of pomp, the Petit Trianon to offer shelter from the relentless demands of those necessities. But as the eighteenth century progressed, informality, ease and natural grace came to be highly valued and generally accepted by the court and the aristocracy as the norm of social conduct.

3

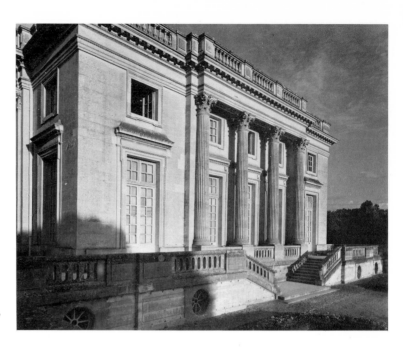

Ange-Jacques Gabriel,
Petit Trianon, Versailles,
1762–8.

Royalty had had the status almost of a legend. The gradual de-
mythification which took place in the eighteenth century reflected
not only the greater sense of political reality shared by many mon-
archs, but also a decline in the need of the people for such tradi-
tions. Queen Anne was the last British monarch to 'touch' the sick
to cure the palsy. The idea that kings and queens were hedged
with an immutable divinity, conferring miraculous powers, was
eroded, not only by political exigency, but by the advance of med-
ical science and the increasingly strong democratic tendencies in
Europe. Thus, by the time of his death in 1715, Louis XIV's image
of the monarchy was already being superseded. Although aristo-
crats, for example, supported monarchs they recognised that their
own acquiescence was a necessary factor in the monarch's survival.

Prosperity made the middle classes more aware of their own
potential, politically, socially and artistically. Social and cultural
improvement may have been inevitably beyond the reach of almost
anyone born into the working and farm-labouring classes. But pat-
ronage of the arts did become more feasible for the ordinary
well-off middle-class merchant or businessman. French and
British painters followed the Dutch and Flemish artists of the sev-
enteenth century and produced appealing domestic scenes and
elegant fantastic landscapes which could hang in modest homes.

Henry Walton's portrait shows the sort of prosperous family
that best represents the social class that did well in eighteenth-

4

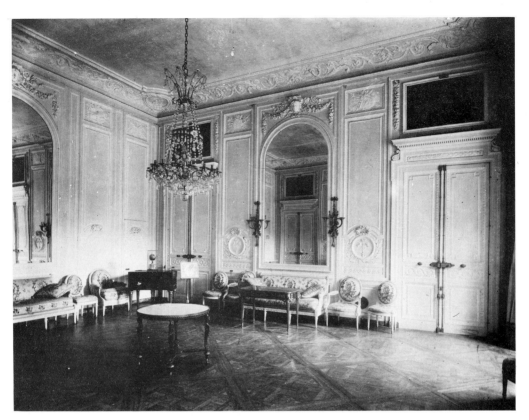

The grand salon, Petit Trianon, Versailles.

century England. They display a considerable degree of comfort and elegance in their daily world. The mother and father sit on a sofa upholstered in the modern manner. The full upholstering of ordinary furniture did not become general before the 1750s. Until well into the later part of the eighteenth century upholstery often meant no more than a moveable cushion. The family reads a book, another indication of the spreading education and interest in intellectual matters which characterise the age. Book production had become cheaper and, like other industrial processes, large scale. Books were first bound in paper wrappers. The bookseller, then also often the publisher, would have them bound in a simple cloth and leather binding, or he might offer them to richer customers who could afford their own choice of leather binding, in varying degrees of sumptuousness. The rich dilettante collector might have books elaborately bound to match the rest of his large library. Walton's family would probably have had their books bound in durable, but elegantly simple, leather. They might have collected a small library of novels, sermons, selected poetry and so on.

Rich men of taste, amassing books on art and architecture for

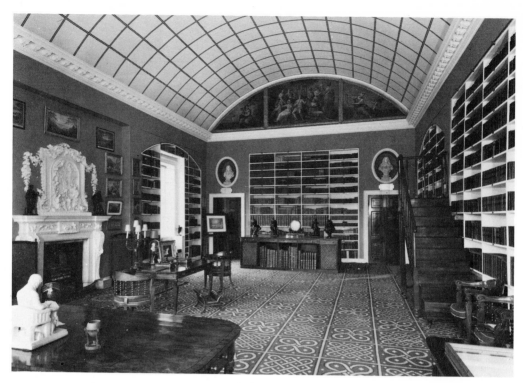

The Library, Stourhead
House, Wiltshire
(National Trust), 1792.

carefully planned book collections, created serious comprehensive
libraries. Architectural drawings, measured plans of ancient ruins
such as those newly discovered at Pompeii and Herculaneum, illus-
trations of Rome and Greece – all these filled the lavish
folios published by designers and scholars. They lined the shelves
of elegant libraries like that of Sir Richard Colt Hoare at Stour-
head in Wiltshire. Such a room indicates the power of the printed
word, which swept Europe with a passion for classical art and
architecture.

THE GRAND TOUR

Most of these collectors wished not only to read of buildings, but
also to visit them. The Grand Tour might be an intensive course
in the languages and heritages of half a dozen European nations, or
simply a prolonged foreign holiday for the idle children of the
nobility. Young men could acquire fluency in foreign languages,
the social graces of European society, and a knowledge of the
ancient world and its remains. Latin and Greek were still the main
staples of education in the period. They formed the basis for any

6

informed understanding of history, literature and art. At its best the Grand Tour educated young men into an appreciation not only of modern art but also the traditions on which it was based. But tutors were expected to educate their pupils by introducing them to life in other ways: the Madams of the better brothels were employed to initiate young bloods into more than a love of art.

Johann Zoffany's picture, *The Tribuna of the Uffizi Gallery*, shows an imaginary, indeed ideal, gathering of dilettanti, amateurs of the arts, and socialites, amateurs of life, in the rotunda of one of Florence's famous art galleries. Zoffany did not draw his scene from life. It was commissioned by Queen Charlotte of Britain who wanted a picture of the finest pieces in the gallery. Zoffany took the opportunity to celebrate one of the highest forms of educated pastime, the connoisseurship of the fine arts. The picture encapsulates much that must be understood for the full appreciation of eighteenth-century art and society.

Zoffany has brought together the most revered pieces from an admired collection. Titian's *Venus of Urbino*, the archetype of female grace in art, dominates the scene. *St John the Baptist*, Raphael's masterpiece of classical male anatomy, hangs on the wall behind. Artists such as the Carracci, Pietro da Cortona and Rubens are in this roll-call of the old master painters. The bust of Julius Caesar, the noble Roman general and politician, lies in the left foreground lending to the occasion the gravity and dignity prized by eighteenth-century philosophers. Around, among and between these peerless works hover, gesticulate and gossip the British community of Florence. Here in argumentative elegance, intellectual eagerness and pride are gathered men whose fertile and receptive minds typify the breadth of interest and liberal attitudes of eighteenth-century culture. Their social education moderates their arguments, subordinating them to the requirements of manners. Enthusiasm is tempered by wit, indolence by genuine interest. They are of course a leisured and privileged few. Sir Horace Mann, wearing the Order of the Bath, stands on the right. He was a collector, diplomatist and recipient of some of the most brilliant letters of Horace Walpole's fascinating correspondence. Such a man, with friends at every court in Europe, steeped in the art of the Renaissance, alive to the discoveries of modern archaeology,

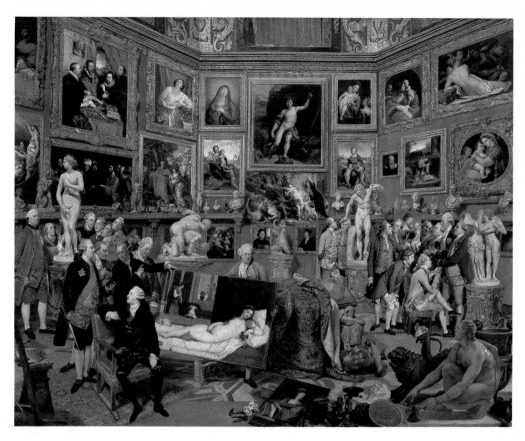

Johann Zoffany, *The Tribuna of the Uffizi*, 1772–80, oil on canvas, 123.5 × 154.9 cm, Royal Collection, Windsor.

must be the exception rather than the rule. But such men as these, with taste acquired in the study of the great art of the past, were the informed initiators of artistic innovation in the eighteenth century. That intuitive and easy elegance is the most prevalent characteristic of the age in art and in society.

THE ACADEMIES

The money of these men made much of eighteenth-century art possible. In the portrait group of the members of the English Royal Academy, which Zoffany also painted, we have an example of the other half of that creative alliance. The Royal Academy, founded by Sir Joshua Reynolds in 1768, was set up to inculcate in its pupils the correct education for an artist. That education was classical and academic, and in this picture we have the most concise statement of what we mean by those words in an artistic context. The painters and sculptors are gathered in the life class,

8

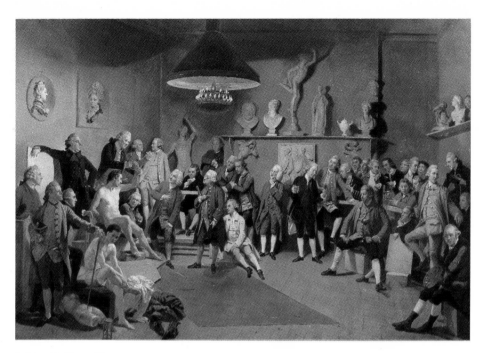

Johann Zoffany, *The Academicians of the Royal Academy*, oil on canvas,
100.7 × 147.3 cm, Royal Collection, Windsor.

the studio in which students drew from the live model. This was an essential element in a classical artistic education, because the human body, refined and idealised by the painter or sculptor was considered the highest form for the expression of pure beauty. Just as the Greeks and Romans had used the nude figure as the visual metaphor for their gods and goddesses, so the eighteenth-century artist sought to create ideal figures, representing high principles and unsullied beauty. This was the finest and most gracious expression that art could attain. Draughtsmanship was the medium through which the student learned to express this beauty. Drawing was the basic discipline which every artist must have before he could use colour, paint or any other additional aid.

The Royal Academy was one of many European academies in which this rigorous training was pursued. The French Academy and its outpost the French School at Rome, together with the Accademia di San Luca in Naples were other similar institutions.

A student in an academy would be set long hours of copying from classical statuary, perhaps from plaster casts of some of the masterpieces in the *Tribuna* painting. But this was copying only from anatomy that had already been refined and idealised by other artists. The most difficult course of study was in the life class, because there the artist learned to extract from nature only those elements necessary to ideal art.

9

2 Rococo art and architecture

The adjective Rococo is supposed by dictionary definition to derive from *rocaille*, which is a kind of shell or pebble decoration, often used in grottoes and gardens in seventeenth-century Italy and subsequently in France. But the word has no precise meaning, except perhaps in the intricacy of its syllables, which tumble like the splashing water and expansive foliage of the style itself. Neither the adjective nor the style it describes is intellectually precise: both are expressions of immediate pleasure, in the sound of the word or the complexity of the ornament.

The Baroque style that dominated European art in the seventeenth century had a serious and dramatic motivation. The absolute truths of resurgent triumphal Catholicism were asserted in stone, plaster and gilded decoration in every Baroque church. Classical architecture with its sober columns and careful proportions acquired a vegetable life. The regulated acanthus leaves of a Corinthian capital climbed and twisted with increasing vigour. Rocks broke like waves at the feet of saints whose bold gestures thrashed their marble robes into tormented folds. Beneath the dome of Saint Peter's in Rome, Lorenzo Bernini, the master sculptor of Roman Baroque art, set his dynamic apostles in telling contrast to the harmonious High Renaissance framework of the great basilica. Here art was being used to fight a vital battle for the souls of all those Catholics threatened by the spiritual turmoil of the Reformation.

These embattled forms, emotionally anguished, spiritually and physically colossal, were the source of the pretty shells and curling tendrils of Rococo decoration. But instead of tormented writhings these forms move with delighted sensuousness, like a girl evading her lover. Pleasure is the principle: like the rocaille patterns of shells and pebbles from which the style derived its name, Rococo art aimed solely to delight a leisured, indeed idle, society, in which the only sin was to be boring.

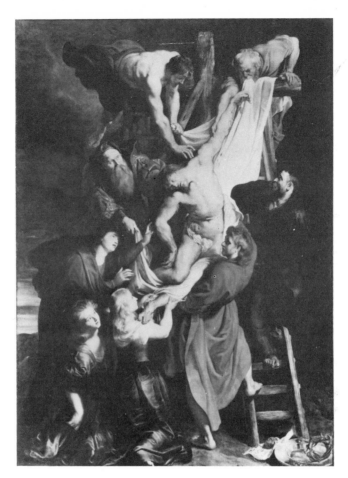

Peter Paul Rubens, *The Deposition from the Cross*, 1611–14, oil on panel, 420 × 310 cm, central panel of triptych, Antwerp Cathedral, © ACL Brussels.

The Flemish painter Peter Paul Rubens was a leading exponent of Baroque. His painting *The Deposition from the Cross* is a famous example of the style. It demands no detailed knowledge of the gospel to understand this as a tragic and emotionally fraught moment in an intensely significant drama. The body of Christ, forming a powerful livid diagonal as it slumps from the cross into the arms of the apostles, is clearly the focus of the scene. The pale and vulnerable form is full of pathos and also dignity. The reaction of the surrounding figures is strong. Christ's death matters to them. The treatment of light is fully Baroque; most significant of all, artistically, is Rubens' use of paint to emphasise the depth of feeling. He lets it sweep across the canvas, outlining more strongly the figure of Christ, carrying something of the downward movement into the brushstrokes. This rich loose handling of the paint, called impasto, is a characteristic of certain types of Baroque painting. Emotion is implicit in the paint as in the subject.

11

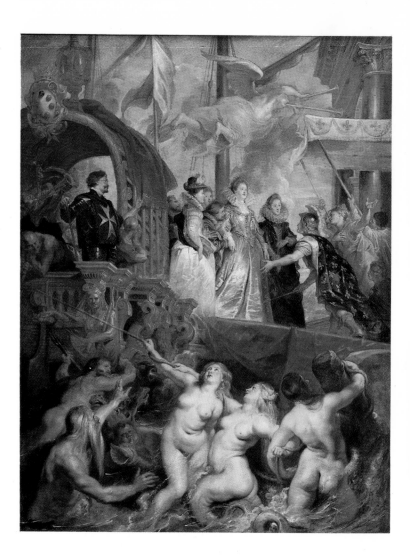

Peter Paul Rubens, *The Arrival of Marie de' Medici*, from the cycle painted for the Luxembourg Palace, 1622–5, oil on canvas, 349 × 295 cm, Louvre, Paris.

The exciting possibilities of Rubens' use of paint attracted artists to experiment with new ideas. At the same time, aristocratic society was receptive to innovation in art. The high Baroque style which Louis XIV had used so effectively for propaganda fell from favour later in his reign. With the establishment of peace and prosperity it was not essential for the king always to be *Le Roi Soleil*, a distant and dazzling sun in the world of court ritual. Formality gradually gave way to informality. Lightness of touch in art and in social relations became more highly regarded at court. But Louis still kept the aristocracy close about him at Versailles, obliged to attend an unending round of levées, receptions and balls. He effectively deprived them of all power in the country. This made them far less of a threat to the absolute power

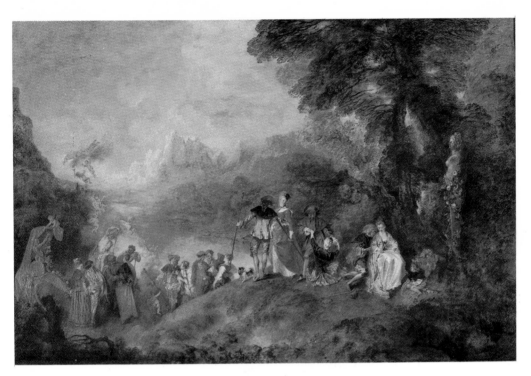

Antoine Watteau,
Embarkation for Cythera,
1712–17, oil on canvas,
129 × 194 cm, Louvre,
Paris.

of the king, but it also created the problem of how to occupy them at court. Ritual and meaningless duties were two answers, but it was necessary to create a world in which the occupations of the idle appeared important. Romance was an antidote to boredom, and, finding themselves with leisure, the courtiers devoted themselves to intrigue – both romantic and political. They found that these ideas were present in the works of painters who, inspired by Rubens' manner of painting, had created an idyllic world of art which reflected the ideals and preoccupations of their lives. The foremost and first of these artists was Antoine Watteau.

WATTEAU AND THE FRENCH SCHOOL

Watteau was born in 1684 in Valenciennes, a Flemish town annexed by France. He grew up in the atmosphere of Flanders, the home of Rubens, but under the rule of France, the nation in which his artistic creations were first appreciated. Like a number of other Rococo artists and architects he was not wholly French, and perhaps, therefore, was well suited to understand and introduce a rather foreign style. He studied under Claude Audran, keeper of the picture collection in the Luxembourg Palace at Paris.

Antoine Watteau,
Embarkation for Cythera,
detail.

There he saw, and copied copiously, Rubens' great canvases of the
the life of Marie de' Medici. These form a series of decorative pan-
els illustrating and celebrating the life of Marie, daughter of the
Duke of Tuscany, who married Louis XIII.

In the scene of her arrival in France she descends from an ornate
barge, to be greeted by ecstatic nymphs. In the picture fact ming-
les with fantasy for, though the arrival is historically true, the
artist takes the licence of representing the welcome of France to its
new queen in the form of allegorical figures. Allegory, the evoca-
tion of an idea in idealised physical form, is an important tool in
large-scale Baroque painting. Elements of the same technique are
also important in Watteau's art.

The drawings and studies he made from this cycle of pictures
became for Watteau a visual encyclopaedia throughout his artistic
career. His imagination fed not on life but on other art. He thus
distanced himself from reality, but at the same time created an
idealisation which tells us much about the world in which he lived
and worked. The way in which these truths emerge is best seen in
his masterpiece, the *Embarkation for Cythera* (p. 13). This is the

14

most famous example of a painting in the *fête champêtre* genre, showing scenes of elegant society in park-like settings. Watteau began the painting in 1712 and worked on it for five years. He put into this allegory, of which three versions exist, not only the mature years of a short career but the distillation of an age and way of life. The theme is the worship of love. Cythera is a real island in the Mediterranean, the scene of ancient pagan worship of Venus. But the frail and graceful figures descending to the boat represent ideal lovers sailing not to the altars of the goddess of love but to an undefined place where romance thrives eternally. It is equally possible to see these figures as any group of French courtiers embarking from a park upon some pleasure trip. The thrill for the aristocrats who saw such a picture may have lain in the implication that some high romantic aspiration inspired their own elegant, but pointless existence. They could identify with the painted figures and, ironically, in doing so, model their lives more closely on Watteau's image, until life and art became inextricably entwined.

To the spectator it is as if one stands on the boundary between waking and dreams. The landscape might be that of any chateau, but across the lake the swathing mists may conceal anything, and, even if Cythera lies beyond, it is most real in the imagination of the journeying lovers. The strong impasto painting often used by Watteau's master, Rubens, is here diluted to a liquid freedom of paint, vital but fragile in the artist's hands, evoking the play of light on satin and foliage. The evaporation of the scene in mist might almost be the final liquefaction of Watteau's palette of colour in the mists and the water. Yet at the same time this technique is elaborately and attractively decorative. The barge which lies at the lakeside is as elaborately ornamented as that of Marie de' Medici. Its stern is dominated by the shell, or *rocaille* motif. The cherubs who hang in the air on their cloud, are curling and decorative elements. This decorative style appealed to eighteenth-century patrons and appears to best effect in the interior decoration of Rococo rooms, where the painting of Watteau and his followers often formed part of the overall decor.

A unity of effect was possible, similar to the unity of Baroque art, which brought painting, sculpture and architecture together in one overwhelming whole. In the *Embarkation* Watteau uses the

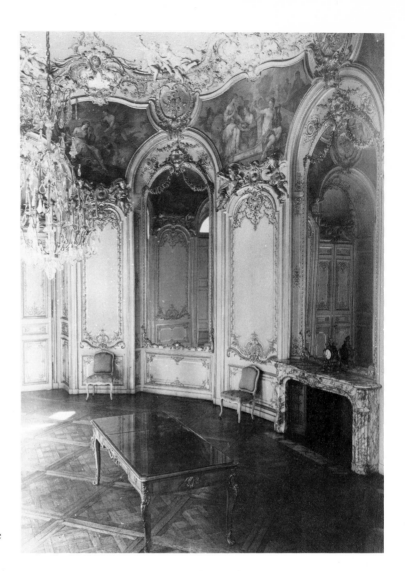

Germain Boffrand &
Nicholas Pineau, Salon
de la Princesse, Hotel de
Soubise, Paris, 1736–9.

Rococo shell motif, together with leaves, branches, flowers, clouds
and other natural forms, to make what is called the 'vocabulary' of
ornament for the Rococo style. The same vocabulary can be seen
in the Salon de la Princesse, Hôtel Soubise (1736–9) designed by
Germain Boffrand who employed the leading designer of the day
Nicholas Pineau to create the extravagant ceilings, picture frames
and panelling with their twisting curling fronds of plasterwork,
delicately shaded panels of painting and richly reflective surfaces.
One's eye is drawn in and out of the complicated patterns, and
there is everywhere a lift, a sense of joy in the possibilities of art,
which takes hold of the spectator and involves him as fully in the
emotion of the moment as does a Baroque altarpiece.

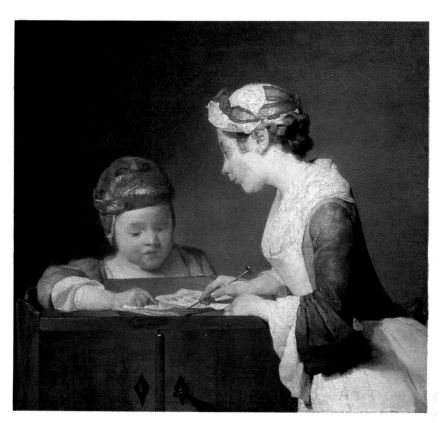

J. B. S. Chardin, *The Young Schoolmistress*, *c*.1740, oil on canvas, 61.6 × 66.7 cm, National Gallery, London.

THE RÉGENCE IN FRANCE

Something of that sense of joy is also present in the society which lived in these surroundings. When Louis XIV died in 1715, a regency was formed for his young son, Louis XV. While the king was still a child the court moved from Versailles to Paris. This brought the courtiers into contact with the rich and successful businessmen and financiers in whose hands the government of the French economy had been placed. These tax-officials, bankers and other professional men had done well out of the secure and prosperous economy created by the old king. They had been excluded by birth from the society of the court, but now, with the relaxation of stringent rules of etiquette, and the return of the court to Paris, they were able to mix with the aristocracy more freely.

The prosperity of the upper middle classes also made them ideal patrons of the arts. Patronage as a form of personal prestige was one way to be accepted in society. Patrons liked novelty and so the new Rococo style flourished in the *régence*. Small-scale, domestic

art found a ready market. Much of it was directly in the Watteau tradition. One artist, who had private means and could pursue his own ideas rather than follow the dictates of a patron, was Jean Baptiste Simeon Chardin.

When we look at Chardin's still, clear little canvases of bourgeois domestic life, we cannot immediately see a connection with Watteau but he in fact exploits the properties of paint as fully as Watteau if in a different way. His subjects are bathed in a steady enveloping aura of light. The light speaks to us through the medium of the paint, and thereby defines the form of the figures in the picture. Chardin's pictures have a strong sense of design.

Design in a painting of any age is the characteristic that most unifies the various elements portrayed. A figure is always understood by the spectator visually, whether in life or art, in relation to its surroundings. The artist who can contrive a proportion between the furniture of a room and the people in it or place convincingly a figure in a landscape so that the arrangement seems inevitable and right, has a mastery of design. In this Chardin excelled. *The Young Schoolmistress* is not so much about the scene with the child and his tutor, as about how these figures stand in the space of the canvas. The play of light convinces us entirely of the volume of the space around the two figures. The clarity of design in the painting excludes any other possible placing of elements in the composition. This balance, a stillness of harmony achieved, is the quality which distinguishes Chardin's art. It was important to the artist, and its importance is felt instinctively by the spectator. There is a sense of complete satisfaction in these little works, even when the technical implications of that satisfaction are carefully disguised. Chardin's paintings are also interesting because they record precisely the everyday facts of domestic life in France. They present a very different world from the artificial courtly fantasies of most Rococo painting, yet they are a part of the same artistic movement. There is the same light touch in the handling of paint, but Chardin differs from Watteau in taking mundane images from daily life and enhancing them with his art. Chardin was fortunate: his wife had money and he did not have to pursue courtly favour. Instead of pandering to the aristocracy he sat quietly in his own kitchen and painted what he saw with a fidelity and delicacy that enhances the

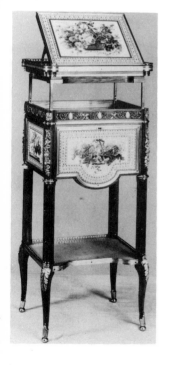

Regency combined work-, writing- and reading-table. Made of oak veneered with tulip-wood, with bronze mounts, chased and gilt, it is decorated with panels of Sèvres porcelain.

simplest pot or pan and distills the everyday into something which remains of great beauty for the modern spectator.

Indeed under the regency of Louis XV the worlds depicted by Watteau and Chardin were no longer so far removed from each other. Ambitious parents might hope to forward their children in society through introduction to court circles. One means of advancement, recognised at court, was the unofficial but powerful appointment of 'favourite' to the king. The broader morality of the age recognised that, when royal marriages were inevitably arranged for political or dynastic reasons, monarchs must have some outlet for their passions. Every king of France was expected to have a mistress. Whoever was chosen exercised great social and political power. In many cases these women also greatly influenced the patronage of the arts.

MADAME DE POMPADOUR AND THE COURT STYLE

Louis XV's most famous mistress, Jeanne Antoine Poisson, became famous as the Marquise de Pompadour. She was the most effective patron of Rococo artists at the court, commissioning buildings and paintings which form the highpoint of Rococo achievement. Her portrait by Francois Boucher reveals both the power and the vulnerability of her position. Madame de Pompadour comes to us unadorned except by her own beauty and the luxuriant folds of her dress. This shimmering expanse of satin is as much as anything the subject of the picture. Female grace is the essence of this likeness. Through grace and intelligence she rose to power and she also made Boucher the most fashionable painter of his day. This portrait is, therefore, a perfect match of means to ends. It presents the great beauty of a highly skilled mistress. It elaborates and glamourises the rich play of light and shade over the fabric of her dress. It is in the most subtle way possible a painting entirely about feminine allure.

The charm of Boucher's portrait of Madame de Pompadour is obvious. The subject and the sitter delight the eye. However, in the ease with which Boucher and his followers could captivate their patrons lay the seeds of another, less attractive, preoc-

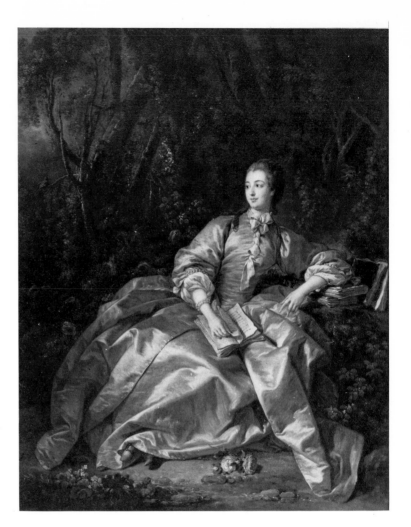

François Boucher,
*Jeanne Antoinette
Poisson, Madame
Lenormant D'Etoiles,
Marquise de Pompadour*,
1758, oil on canvas,
52.4 × 57.8 cm, Jones
Collection, Victoria and
Albert Museum,
London.

cupation. In the hands of Boucher's pupil, Fragonard, the glam-
ourisation of sex caters more overtly to the sensual tastes of the
artist's patrons. *The Swing* is in many ways the fullest expression
of this interest of both artists and patrons of the Rococo style.

The highly refined handling of the paint expresses the forbidden
nature of the subject: a nobleman's glimpse beneath a girl's billow-
ing skirts. The surface almost literally froths with the intimation
of illicit pleasure. The presence of the cleric pushing the swing
only adds to this voyeuristic atmosphere. It is an astonishingly
frank work, especially when one remembers that the girl probably
wore nothing under the skirt, and far removed from the elegiac
mood of Watteau, though indebted to it in conventions and treat-
ment.

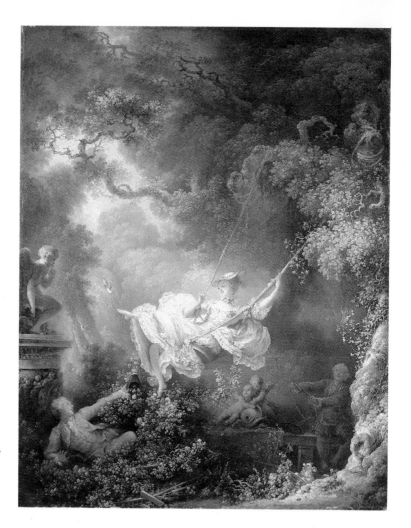

Jean-Honoré Fragonard, *The Swing*, 1768, oil on canvas, 82 × 65 cm, The Wallace Collection, London.

THE SPREAD OF THE ROCOCO IN ENGLAND

French artists and those who had studied in France travelled widely in Europe taking the new court style with them.

In England Rococo painting had a vogue but only a relatively brief one. The Hanoverian court, a product of George I's and George II's provincial German taste, was different from the French court. William Hogarth, the most distinctively brilliant English artist of the early eighteenth century, assimilated the free handling of paint and pastel colours of Rococo art, but guyed the conventions mercilessly. He visited France but disliked the French and their world. He used the style, but being an Englishman he adapted it to more informal and less aristocratic ends. In *Before* and *After* the rustic lovers have become a debauched young man

21

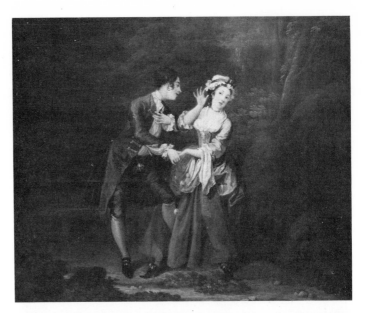

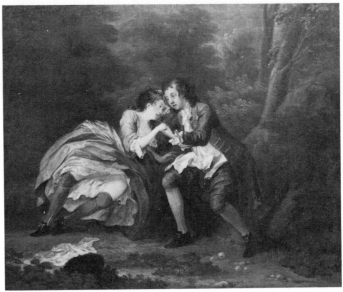

William Hogarth, *Before* and *After*, 1730, oil on canvas, 37.2 × 44.7 cm and 37.2 × 45.1 cm, Fitzwilliam Museum, Cambridge.

and a disgruntled parlour maid. Their romance is abortive and feverish, its consummation anticlimactic and acutely uncomfortable and a clear parody of the French equivalent – the courtly world portrayed by Watteau. Hogarth is pragmatic, and earthy realism was more in keeping with the British character. It is not surprising that the purposes and qualities of Rococo art never really took root in Britain.

However, the style did permeate the London art world for a brief period. Francis Hayman's *Dance of the Milkmaids on May*

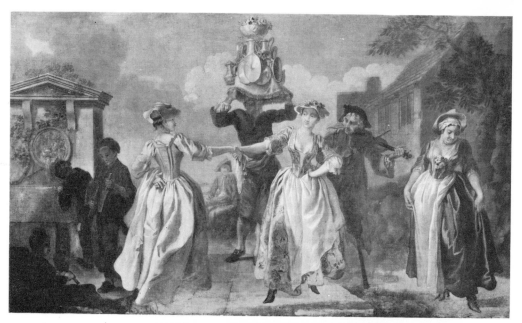

above: Francis Hayman,
*Dance of the Milkmaids
on May Morning*, c.1750,
oil on canvas,
138 × 240 cm, Victoria
and Albert Museum,
London.

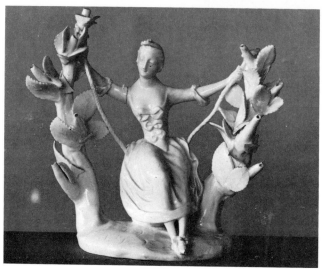

Girl in a Swing,
Porcelain figure group,
c.1750, height 15.9 cm,
Victoria and Albert
Museum, London.

Morning is one of the most delightful expressions of the unsophis-
ticated and gently realistic vein of Rococo painting in Britain. Like
Boucher, Hayman is fascinated by the silvery effects of light on
satin. But his high-spirited farm girls performing their jig through
the fields from Highgate into London, are more prosaic manifes-
tations of female charm. A piece of porcelain of the same decade
catches the naïve grace in British art, and the freshness of its ex-
pression. The frail figurine is a candlestick: the tree stumps that
support the swing were intended for holding candles. The piece

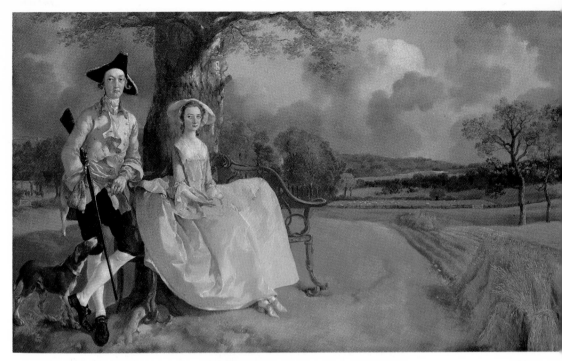

Thomas Gainsborough,
*Mr & Mrs Robert
Andrews*, c.1748–50, oil
on canvas,
69.8 × 119.4 cm, The
National Gallery,
London.

was unpainted, in contrast to the sophisticated colouring of most French porcelain. In mood this young girl in a swing, balanced precariously in broad pannier skirts, is closest to the early master-pieces of the only great Rococo painter of England, Thomas Gainsborough.

THOMAS GAINSBOROUGH

Gainsborough was a countryman born in the county of Suffolk in 1727. He studied art in London under a French engraver, Hubert Gravelot, but had little time for the extreme unreality of the supposedly rural *fête champêtre* depicted in paintings like Watteau's *Embarkation*. He was well aware of the muddy fields beyond the park gate. His intuitive sympathy with humanity, similar to that of Hogarth, though less satirical, enabled him to portray believable people and invest them with some of the grace and wit of his French forerunners. In an early masterpiece, *Mr and Mrs Robert Andrews*, the French *fête champêtre* is transposed to an English farming estate. The picture is the Andrews' wedding portrait and says as much about their social status as their character. Mrs Andrews' blue silk dress is evidently worn with a proud swagger of

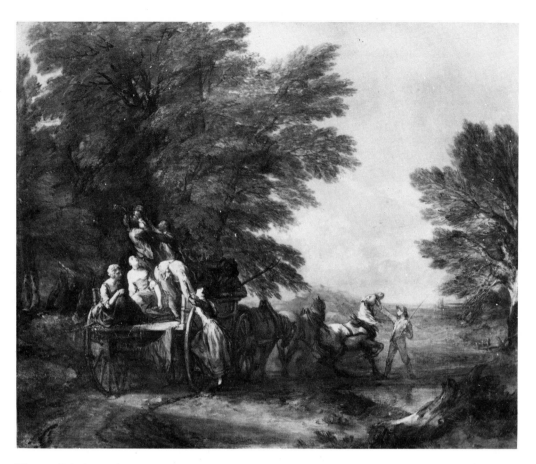

Thomas Gainsborough,
The Harvest Waggon,
c.1767, oil on canvas,
120.5 × 144.7 cm, The
Barber Institute of Fine
Arts, Birmingham.

ownership, slightly undermined by her uneasy perch on the imagined Rococo bench. She is as delicately balanced in her pannier skirt as the 'girl-in-a-swing' figurine.

Gainsborough learned his trade painting the local gentry and could, as a bonus, indulge his love of landscape in the background to the scene. Even later in a highly successful and fashionable career as a portrait painter he never allowed his landscape painting to take second place. He rarely attempted the grand classical painting of contemporaries like Sir Joshua Reynolds (see below p. 52) but he could use themes and ideas from the grandest pictures for his own works. In the *Harvest Waggon* the pyramidal group of figures is based on Rubens' *Deposition* (see above p. 11), which Gainsborough knew from an early Rubens' sketch. Such a composition is harnessed to his delight in landscape. His genuine knowledge and love of country life is expressed with great vitality in the vivid brushwork and free handling of paint he had learned from French Rococo painters. Unlike Watteau's *Embarkation*, the

25

misty depths of this richly evocative study of harvesters in a land-
scape conjures up the dignity and humour of real people.

THE ROCOCO STYLE IN ARCHITECTURE

Romance, which fed the imaginations of an exhausted aristocracy,
characterises the French contribution to the development of
Rococo painting. The interiors which accompany that style are
expressions of the desire to distract the eye and decorate the world
of the imagination. In Britain Rococo art never took hold, and
architecture took little account of the style. It is interesting to
note that landscape was the passion of the only major Rococo
artist, Gainsborough.

Each country reflects to some extent in its art the preoccupa-
tions and prejudices of the society which it fosters. Of the
European nations only Austria and the German states, nominally
still politically subject to the ancient Holy Roman Empire, and
still owing in religious beliefs loyalty to the Catholic Church,
explored thoroughly the potential of the Rococo style in architec-
ture. Southern Germany and Austria had been swept by the
fervour of the Counter-Reformation. While France remained anti-
papal though fundamentally Catholic in outlook, and Britain and
the Netherlands and northern Germany supported Protestant
reforms, in Austria and southern Germany the spiritual and
political influence of prince-bishops was unabated.

Many of these ecclesiastical rulers maintained courts in great
style and encouraged the arts. Baroque artists had put across their
message simply and forcefully, and Baroque architecture asserted
political and religious dogma in uncomplicated and compelling
terms. Rococo architecture asserts the principle of pleasure,
whether in response to the glorious news of salvation, or the
impetuous delight of sensuous response to the physical world.

The foremost architect of this age was Balthasar Neumann,
architect to the Prince Bishop of Würzburg. His masterpiece is the
pilgrimage church of Vierzehnheiligen (the fourteen saints to
whom it was dedicated). Pilgrimage may sound a medieval idea,
but then these small southern German states were still part of a

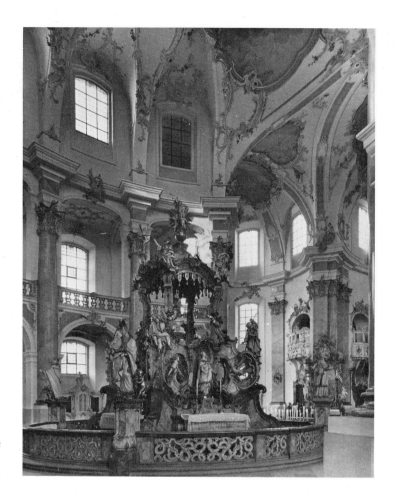

J. J. M. Küchel,
Gnadenaltar, at the
centre of the nave of the
abbey church of
Vierzehnheiligen, 1764.

deeply religious world. The faith was simple, the appeal to the
faithful as direct as that of a Gothic cathedral. The difference was
that, where a cathedral might bring you to your knees, gazing east-
ward to the impenetrable mysteries of the mass, the Vierzehnheil-
igen draws those inside together in an enveloping world of light,
colour and illusion. It is impossible to say where wall ends and
plasterwork begins. It is equally impossible to understand the
whole structure of the church. It is an elaborate exercise in mysti-
fication, presenting different facets to the spectator from different
angles. The church was completed after Neumann's death, the
stucco being the work of J. M. Feichtmayer, the frescoes of
G. Appiani.

The central activity of the Catholic church, the celebration of
the mass, is expressed in the central feature of the building, a
Gnadenaltar which one writer has inimitably described as 'a gor-
geous object, half a coral reef and half a fairy sedan chair'.

27

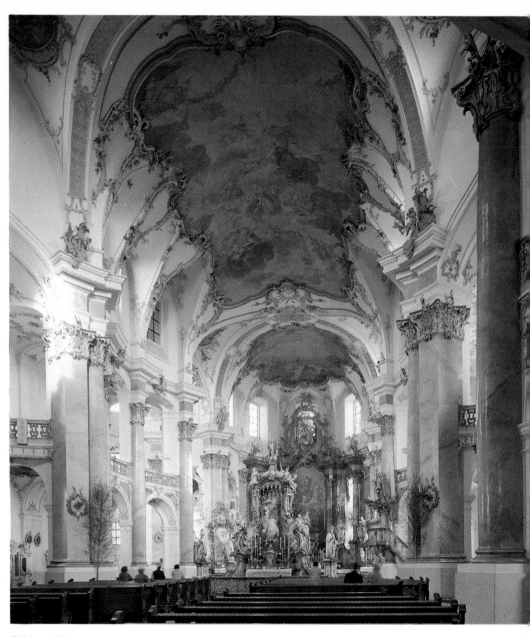

Balthasar Neumann,
Vierzehnheiligen,
Germany, 1743–72.

What are the connections between this extraordinary work, and
Rococo ornament and decoration in Europe? There is an obvious
common factor between this architecture and painting and furni-
ture in France and England; it is to be found in the lovely sinuous
lines, tumbling in the mists of Cythera, in the foliage of Gains-
borough and in the riot of stucco of the Vierzehnheiligen. All these
creations share a pastel palette; the delicate pink and gold of the

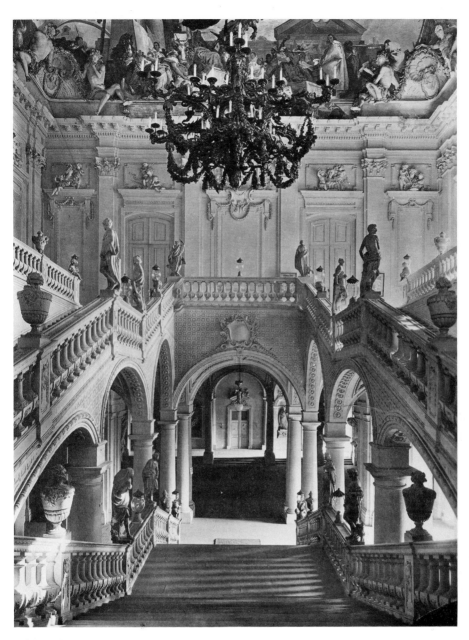

Balthasar Neumann,
staircase of the Bishop's
Palace, Würzburg, 1737–
42.

church recalls Boucher's effervescent silks or Hayman's ebullient milkmaids. Perhaps the most precise adjective is freshness. Even the veiled salaciousness of *The Swing* is fresh with the bubbling froth of Fragonard's brushwork. There is sheer delight in Rococo art as in no other style. The staircase of the palace of the Prince Bishop of Würzburg, built by Neumann and painted by perhaps the most brilliant of Rococo decorators, the Italian Giovanni

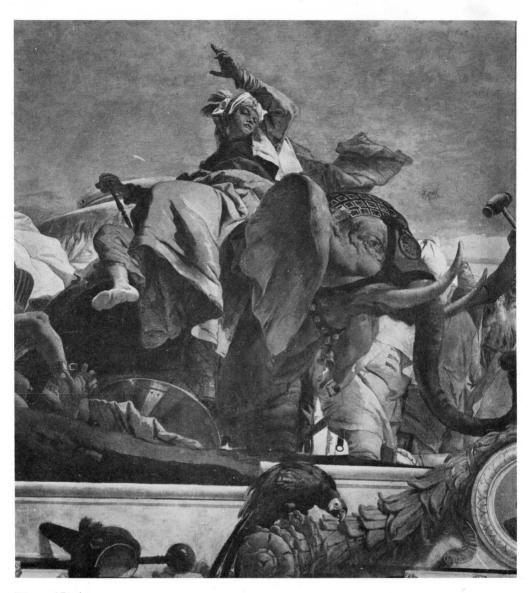

Giovanni Battista
Tiepolo, detail of the
fresco, Bishop's Palace,
Würzburg, 1752–3.

Battista Tiepolo, is a celebration of this world in all its diversity. Four continents come together in a pageant of colour and form. Elephants and blackamoors, nymphs and tigers, piled high like some Emperor's triumph, celebrate the varied and remarkable creatures of the earth and suggest that the bishop took pleasure in life as God's creation and gift. This is a reasonable response to the truths of religion and an aspect of the age which is often lost in more secular manifestations of art and philosophy.

3 A new ideal: the Neoclassical vision

It is very simple to describe Rococo art as a carefree and emotional response to the material world, and to regard Neoclassical art as a revulsion of intellect against instinct. Rococo artists certainly appealed to their patrons, as we have seen, by creating an idealised world. This world touched at certain points the existence of their leisured patrons, but expanded those limited horizons. The artist could choose between the lords and ladies of the *fête champêtre* and the gods and goddesses of Olympus, Cythera or Arcadia. The appeal here is apparently to the heart, but relies on the charm of an intellectual notion: that the world of the French court is the court of Zeus. There was never in fact a time when art appealed only to the intellect. Men and women always sought idealised worlds to emulate or even inhabit. The revival of interest in classical art also evoked an idealised world: not a pastoral idyll but the splendour of a lost civilisation: the liberty of Greece or the dignity of Rome. Yet the appeal of that world is not only to the head, but, partly at least, to the heart. The romance of the ancient world hung about the eighteenth-century dilettante like smoke from the altar-fires of an oracle.

Rome was for every eighteenth-century artist the crucial image and central experience of his career. Each age had rediscovered that city in the light of its own preoccupations. The scholars of the Renaissance found in the poets and philosophers of ancient Rome a literary yardstick against which to measure their own achievements. Eighteenth-century architects recognised in the Roman forum an heroic model upon which to base their own grandiose schemes. Greek architecture was also an inspiration, especially where it was easily accessible, as at Paestum in Italy, where a group of temples survived, built in the Greek Doric order. Athens, however, did not have the advantage of three hundred years as the hub of European creativity since the Renaissance. Rome was accessible, sociable, fashionable. People travelled from

Plate from T. Martyn
and J. Lettice,
*Antiquities of
Herculaneum*, 1773.

all over Europe to make their Grand Tour of Italy. They engaged
guides, or *ciceroni*, to show them the sights and explain the excava-
tions of ancient buildings.

POMPEII AND HERCULANEUM

A contributory factor to the excitement was the constant discovery
of new treasures. The King of Naples was a notable patron,
whose financial support made possible the excavation of Pompeii
and Herculaneum, two Roman cities buried under volcanic ash in
the eruption of Mount Vesuvius in AD 79. From the petrified

32

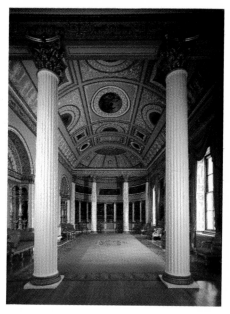

above: Robert Adam, the
library, Kenwood
House, London.

Frontispiece to
*Catalogue of the
Collection of Sir William
Hamilton*, 1790.

ruins it was possible to reconstruct in detail the decoration and
domestic minutiae of an ancient house. These excavations there-
fore made Naples a strong second contender after Rome for the
attentions of Neoclassical enthusiasts. Horace Walpole wrote in
1757 to Sir Horace Mann hoping he 'could by your means pro-
cure ... the account with plates of what has been found at
Herculaneum'. Also at Naples was Sir William Hamilton, the
British Consul, who formed an unrivalled collection of Greek
vases, dredged from the Bay of Naples, the designs of which were
published in richly illustrated catalogues. Such volumes were typi-
cal of the books collected by men of taste.

For those who could not travel to the south, or who required an
aide mémoire of their experience, such folios provided a visual
treasure house of decorative shapes and patterns. Fine editions of
architectural drawings stimulated the imaginations of amateur
architects like Sir Richard Colt Hoare (see p. 6) and profes-
sionals such as Robert Adam, whose library at Kenwood House,
built for Lord Mansfield, is perhaps the most complete British

33

Louis Joseph Le Lorrain, decoration for the Festa della Chinea at Rome, 1746.

evocation of the classical heritage. Nothing, however, could ultimately replace the experience of Rome itself. Among the earliest designers to respond to the stimulus of the great remains of an imperial city were the students from the Paris Academy who visited Rome. This was the final training ground of three generations of the most innovative young architects. Their studies of ruined mausoleums, monuments and temples gave them the raw material for new and startling creations.

Louis Joseph Le Lorrain was one architect whose designs for floats for carnival firework displays, demonstrated, if only in temporary form, the new style. He created from the columns, pillars and rotundas of the ruined temples, a theatrical set piece which must be imagined swathed in coloured smokes and vivid with cascading fire. A constant paradox of classical eighteenth-century architecture is here evident: even the most austere building seeks to create an effect as much as realise a rule. The most academic exercise evokes associations with its ancient source, and this game is as emotive as any Rococo idyll.

THE INFLUENCE OF PIRANESI

Among the many designers working on these themes none produced so coherent and highly personal an interpretation of the city of Rome as Giovanni Battista Piranesi born at Venice in 1720. He was an architect and engineer by training, but his forte was not the

34

Giovanni Battista Piranesi, Felice Polanzani, frontispiece to *Opere Varie di Architettura*, 1750.

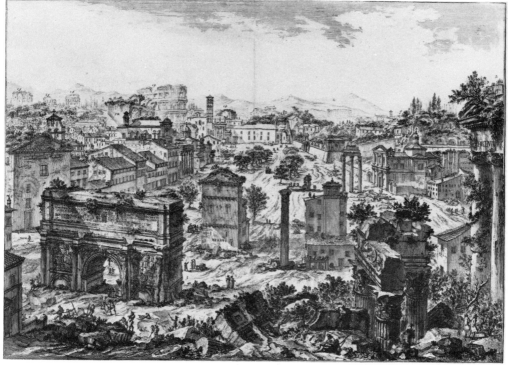

Giovanni Battista Piranesi, View of the Forum, *Vedute di Roma*, 15, *c*.1748–78.

erection of buildings so much as the evocation of ruins. His earliest prints, etched before he left Venice for Rome, have something of the lightness and grace of Tiepolo's style. He grew away from this delight in line and movement towards an obsession with mass and shadow, richly wrought and heavy in its intensity. Piranesi had

35

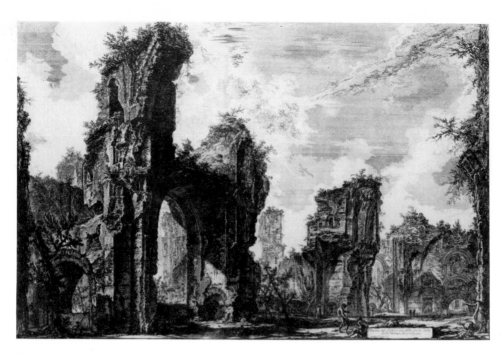

Giovanni Battista
Piranesi, Baths of
Caracalla, *Vedute di
Roma* 77, *c*.1748–78.

none of Tiepolo's sunlit optimism. His character was insecure,
often paranoid – he initiated and sustained some of the more
vitriolic aesthetic controversies of the age and he alienated all
around him who might have helped and supported his ventures.
In 1740 he set up shop as a topographical printseller in Rome: a
trade closely akin to modern-day postcard selling. Gradually the
early literal style of his engravings, which recorded what was
there for artist and tourist alike to see, was supplanted by an heroic
and tragic vision of the memorials of Rome's greatness. Shadows
lengthen and darken, alive with frantic hatching. The knee-
breeched figures who elegantly point out some felicity of decay
little by little lose their nerve and tremble, impossibly small,
before the lowering walls and crumbling arches of temple or bath.
Their insignificance, lost in an alien land at nightfall, threatened
by yawning apertures or mouldering cisterns, is perhaps a measure
of the artist's own insecurity.

Piranesi turned from conventional Roman subjects, the Amphi-
theatre, or the Arch of Constantine, to obscure remains of the
Roman water supply. In one etching the arch of the sewer, the
Cloaca Maxima, imprisons, whale-like, the posturing sightseers.
Piranesi's later, brilliant and desperate suite of etchings *Carceri*
(Prisons) is foreshadowed here. Cells and dungeons filled with
cranes, ropes and pulleys, implying somehow hideous tortures of

36

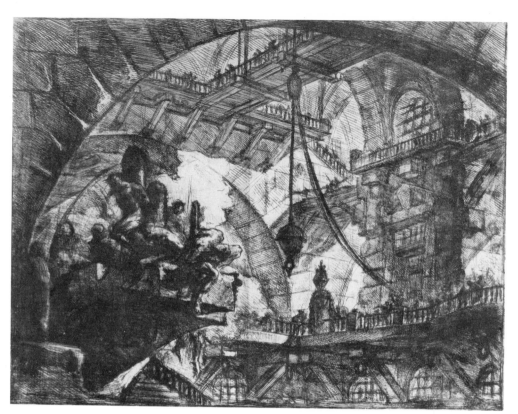

Giovanni Battista
Piranesi, *Carceri*, plate
X, *c*.1745.

the human frame, preoccupied him. The appeal of the original
topographical views was simply that they recorded a scene. In the
later interpretative works, Piranesi impressed on the minds of his
contemporaries an image of Rome outstripping the original in
scale and drama. Walpole wrote of the 'sublime dreams of Piranesi
who seems to have conceived visions of Rome beyond what it
boasted even in the meridian of its splendour'. For students and
designers who came to the city, nothing could equal the imagined
theatre of Piranesi's prints. As propaganda for his contention that
Rome was the source of all great design, the prints were subtly
persuasive; as food for the imaginations of young artists, they were
incomparable.

For these students the Grand Tour was not something to be
taken lightly. In 1749 one serious and influential young man, the
Marquis de Marigny, brother of Madame de Pompadour, set out
for Italy in company with an architect, Jacques-Germain Soufflot,
and an engraver, Charles-Nicholas Cochin. Cochin was, with
Soufflot, an important exponent of classical design. They instilled
in the impressionable Marigny their own fervour for Rome and its

37

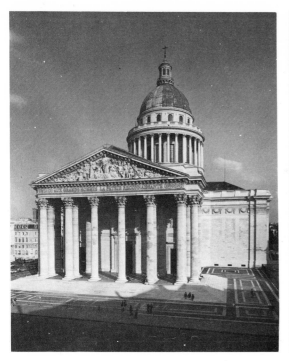
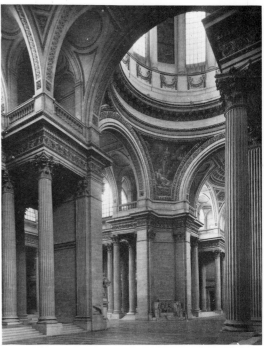

Jacques-Germain Soufflot, Ste Geneviève, now the Panthéon, 1757–92.

works. Since the Marquis was the Surintendent des Bâtiments du Roi (Surveyor of the King's Buildings) his taste was influential and his favour useful. He was shown the sights, had his portrait painted, and commissioned drawings and plans to be carried back to France. With him he also carried back a vision of France, as seen by the new generation of designers: a nation not only of dominant political power in Europe, but also supreme aesthetic authority. The ideal of Paris, reconstructed and ornamented with noble public buildings and grand schemes of planning, lay at the heart of half a century's architectural creativity. The students who had made fantastic designs in canvas and wood for firework pageants were now to realise their projects in stone and marble.

SOUFFLOT AND STE GENEVIÈVE

The Church of Ste Geneviève, conceived by Soufflot upon the purest classical architectural principles, represents thirty years of activity. It was begun in 1757. Building went on until the Revolution, when in 1791 the church became a national pantheon of the heroes of the people. The building, which began as a powerful symbol of ancient splendour revived, was finally to be the symbol

38

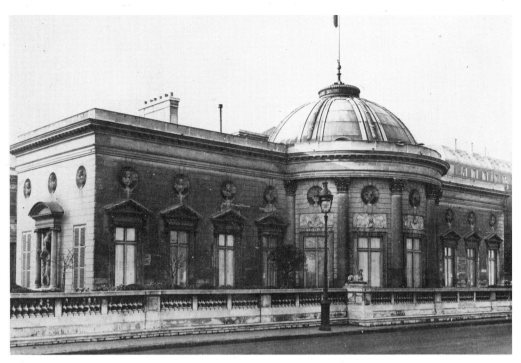

Antoine Rousseau, Hôtel
de Salm, Paris, 1784.

of revolutionary heroism. It is an academic exercise in columnar
architecture, using columns to articulate a structure which is at
once massive and light, overwhelming without, spacious within.
The plan is centralised, a Greek cross, and on entering beneath the
monumental portico one is gathered into a controlled and har-
monious space. How entirely different this is from the Vierzehn-
heiligen, where the riot of ornament and complexity of structure
deceive and distract the spectator. Order and stillness predominate
inside Ste Geneviève; the worshipper is encouraged to bring his
thoughts to bear on a defined totality of doctrine. There is also the
appeal of vast scale and simple architectural elements: the soaring,
fluted line of a column, economically supporting the entablature.
These are ordered responses. But it is also possible to feel like one
of Piranesi's tiny lost figures, casually scratched in for scale by the
engraver's burin.

Such a creation is not intended for the everyday world. Neo-
classicism was, however, not an academic style for great public
buildings only. The purity of design of columns could also be
applied to the less awesome needs of domestic architecture, as at
the Petit Trianon. One of the finest small-scale applications of
these principles was in Antoine Rousseau's Hôtel de Salm in Paris.
Here is the same rotunda or mausoleum motif – the domed temple

39

has been incorporated into a long low facade which easily accom-
modates the rooms of an aristocratic town house. The dome marks
the great ball-room or reception room. Lesser rooms are not given
the same emphasis, but there is interest and animation throughout
the frontage. The niches with the Roman busts, the heavily cut
stone, known as rustication, which imitates the massive blocks of
the Roman baths, and the long windows, enrich this simple
design, so that, while the purity of classicism is observed, the
more relaxed requirements of everyday life are also accommodated.

CHAMBERS AND ADAM: THE DOMESTICATION OF THE CLASSICAL

There is in England only one major public monument of Neo-
classical taste. It was created by the least parochial of English
architects, one of the most influential international designers of the
age, Sir William Chambers. At the same time as Soufflot and
Cochin were tutoring the young Marigny, William Chambers was
preparing himself for his own grand tour by studying in Paris at
J. F. Blondel's Ecole des Arts. He came, therefore, to Rome armed
with a professional training. With cosmopolitan sophistication he
found that Rome fulfilled rather than overwhelmed his expecta-
tions. Unlike his contemporary Robert Adam, the Scottish
architect, he absorbed rapidly and readily the more extreme experi-
ments of Piranesi and the French students. But he was not so
sure of his future that he did not recognise the need to make an
eye-catching debut in England. Adam, who had arrived in Italy
after Chambers, was desperately worried that his rival would re-
turn to win the fashionable laurels before he could assimilate his
own studies and produce designs for potential patrons. The
anxiety of both architects gives something of the flavour of the
intense and exciting competition of the time. Books were rushed
off the press to catch the taste of the rich patron and the magazine
reviewer. Of course the time-lag between study and fruition was
longer in those days: slow travel and primitive technology milita-
ted against instant success. Thus Chambers was still in Italy in
1751 when he heard news of the death of his patron, Frederick,

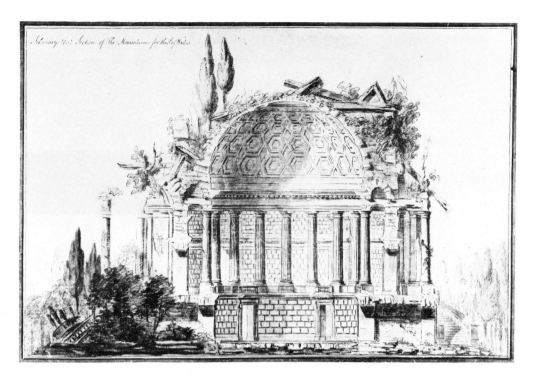

Sir William Chambers,
Design for a Mausoleum
for Frederick, Prince of
Wales, 1752, Victoria
and Albert Museum,
London.

Prince of Wales. This might have been a severe set-back, since the
Prince was heir to the British throne. With great acumen,
Chambers rapidly drew up designs for a mausoleum for the Prince,
to be erected at Kew.

This mausoleum to commemorate a leading patron of Rococo
painting in Britain proved to be one of the most significant
British exercises in the Neoclassical style, a style which Frederick
died too soon to know. The project remained unbuilt, but one
drawing for it anticipates not only the creation but also the decay
of the mausoleum. It is a scene of Piranesian melancholy.
Masonry crumbles, columns lie broken in this most self-conscious
of architectural conceits: the dramatisation of a proposed structure
as a classical ruin. Piranesi had recreated Rome more lyrically,
more magnificently than even its founders. Chambers pays tribute
to that morbid dignity by destroying his own creation, willing his
own walls to fall. Classical restraint is allied to emotional pessi-
mism and collapse.

Chambers' great opportunity to put these notions into practice
came in the single greatest commission of classical architecture in
Britain, the building of Somerset House. This was a piece of offi-
cial architecture which gave Chambers unlimited scope for the
grandiose exploitation of a fine site. There is here no single

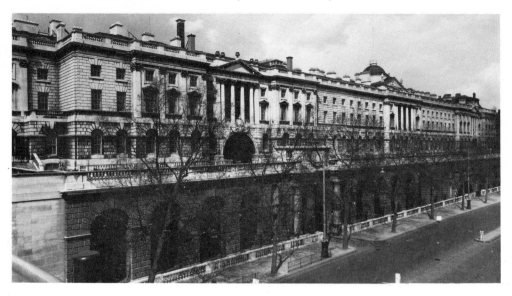

Sir William Chambers,
Somerset House 1776–
80, the river front
showing arcades below
main building.

centralising feature. Chambers reserves the drama and interest of
the great bridges for the pavilions, so that the eye ranges back and
forth along the impressive length, as if following a solemn proces-
sion. The whole composition requires water to complete the effect.
Before the embankments on the Thames were built, the serried
arches of Somerset House gave directly onto the river. Massive
pilasters added weight to an already brooding cavern. To imagine
the approach to Somerset House by water is to approach with fore-
boding the entrance of one of Piranesi's mysterious prisons. What
added to the majesty of this development was the proximity of the
single most ambitious scheme of Chambers' rival, Adam.

Robert Adam had returned to Britain from Italy to build up a
highly profitable and fashionable architectural practice. The aca-
demic precision and weighty archaeology of Chambers' work did
not appeal to the average domestic patron. Adam's appeal was
light and airy, frankly popular. He and his brother James embark-
ed in 1768, eight years before work began on Somerset House, on
an elaborate plan to build a single palatial group of buildings con-
taining a large number of town houses of generous but not lavish
scale. The result was Adelphi, an aesthetic triumph and a specula-
tive disaster. Like Chambers, Adam exercised restraint in the use
of ornament on the facades, to the extent that they were criticised
as 'the finest warehouses in London'. Below, on the river frontage,
as in Chambers' Somerset House, the arcades gave originally on to
the water. What a sweeping gesture both buildings must have
made together, before modern development destroyed Adelphi –

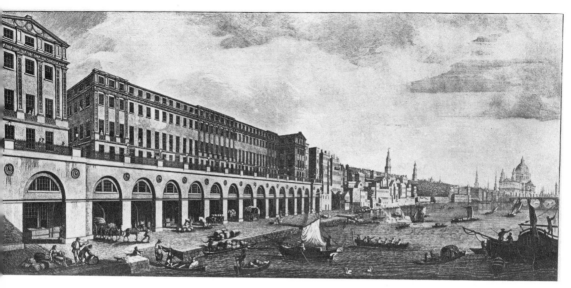

Robert and James Adam,
Adelphi, London, 1768–
72 (demolished 1937).

Chambers' uncompromising exercise in international Neoclassicism, set beside Adam's austere but graceful housing.

Although Adelphi has been destroyed it is possible to get an idea of its quality and suitability for daily life from the drawing room of one house, that of David Garrick the actor, reconstructed in the Victoria and Albert Museum, London. Garrick was precisely the sort of man to whom the light touch and accommodating classical manner of Adam's decorations would appeal. He was a newly rich arrival in the middle classes, an actor who achieved universal fame and social acceptance. He was warm and generous, a friend of many painters and designers. He included Gainsborough and Zoffany among his circle of friends. He was sociable and hospitable. His drawing room must have been an immensely attractive place. It reveals the elegance of this age.

The decoration gives a clear idea of how Adam adapted his sources to suit his own ends. The ceiling is divided by delicate strands of plasterwork into a complex geometrical pattern. Each section is painted, and some have allegorical figures. These are drawn from the decorations at Pompeii, and were painted by a team of artists employed by the Adam brothers: contract artists whose work is often indistinguishable one from another. On the floor there would have been a carpet echoing, without exactly repeating, the ceiling design. The furniture of the Garrick house was painted, again in imitation of Pompeiian examples. The walls were panelled to half height, with elaborate door-frames, then painted or papered above. Everything is in harmony, there is no

43

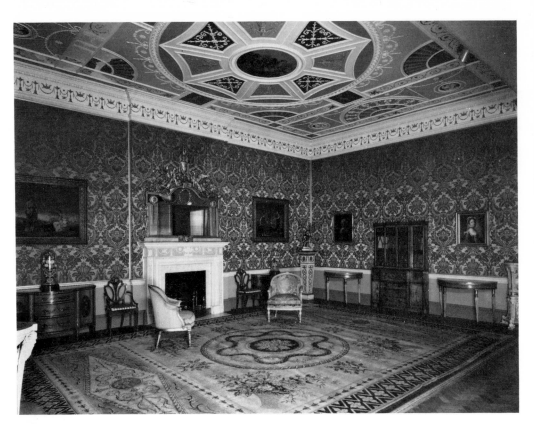

Drawing room of
Garrick's House,
Adelphi, c.1770,
furnished 1771–2,
reconstructed in the
Victoria and Albert
Museum, London.

one element allowed to dominate over its fellows. Even the tea
service is in accord with the classical taste, for the service com-
missioned by Garrick in 1777 survives. It is one of the finest
ensembles of Neoclassical decorative silverwork. The chaste
urn-like form of the vessels, the beaded decoration and the wholly
satisfying proportions of the pieces, illustrate the balance and
grace which could be achieved in matching classical precedent to
modern utility. Garrick and his wife, seated in their modish draw-
ing room, dispensing tea from the service, in a room whose win-
dows commanded a view of Somerset House in its splendour, may
not be typical of most families in England at that date, but they
do give a clear idea of the way an international style could pervade
everyday life.

THE COUNTRY HOUSE

Autocratic government gave French architects an unparalleled
opportunity to exploit the drama and grand scale of Neoclassical

44

James Young & Orlando Jackson, urn and hot water jug from the silver tea service designed for Garrick, 1774–5 Victoria and Albert Museum, London.

architecture. The British rural economy, a social structure in which power and administration often centred upon the local squire, produced on the other hand the glorious achievement of the eighteenth-century country house. Men like Mr Andrews, in Gainsborough's picture, were typical, doing well out of their lands, but also investing in foreign trade or speculating in stocks and shares. The Andrews rebuilt their home out of money made in the West Indies slave trade. A new house was a powerful status symbol, and said something about the attitudes of its owner. Comfortable, high, light rooms with many-paned windows, and elegant and delightful decoration reflected the reasoned and stable system which supported the prosperous family.

The Curzons were a family well able to afford the luxury of thus expressing their power and wealth. They commissioned a new house which was begun in 1759, supervised by James Paine. But while the house was still building they decided, for unknown reasons, to transfer the commission to Robert Adam. The garden front and the whole interior of Kedleston Hall, Derbyshire, are Adam's creation, one of the finest conceptions in eighteenth-century classical architecture. The source for Adam's design of the garden front was the arch of Constantine in Rome, but he has not stopped short at this point, simply reproducing the outlines of a triumphal arch. The two staircases that sweep down into the garden give a powerful dramatic force to the whole composition, and link successfully the upper floor, with its main range of state reception rooms, and the semi-basement on which those rooms stand. The lower floor accommodates general servants' rooms, but also serves to insulate the first floor from damp. Thus this country house is both an evocation of the classical world and an adaptation of it to modern British needs.

Adam was particularly adept at such work. He had a strong sense of drama when creating a vista or handling a single large architectural motif. But he could also work closely to clients' specifications, and his interior decorations form a charming and noble setting for formal and for daily life. The great marble hall at Kedleston is as finely antique a conception as any produced in Britain, but the adjacent drawing room is, though formal, not so stately as to be uncomfortable.

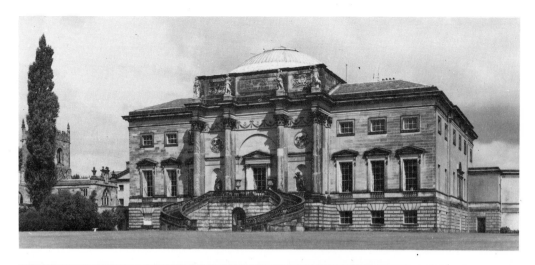

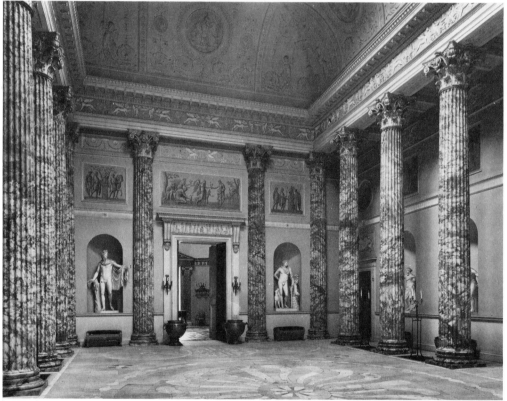

Robert Adam, garden
front (*c*.1763) and
marble hall (1763–77),
Kedleston Hall,
Derbyshire.

In the late eighteenth century a sense of comfort and intimacy
was very often considered desirable. It is useful to contrast
Kedleston with a smaller, remodelled house, like Southill in
Bedfordshire which Henry Holland recast for the Whitbreads, the
famous brewing family, between 1796 and 1806. It is more

46

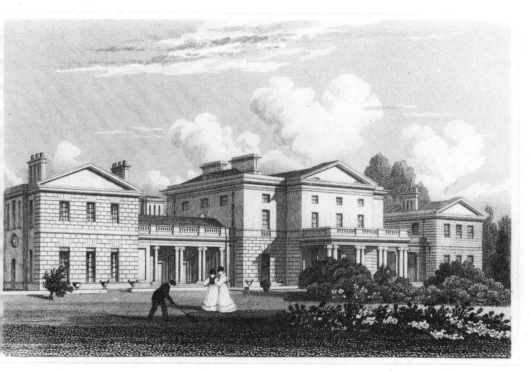

Henry Hollands, remodelled garden front, Southill, Bedfordshire, 1796–1806.

Grecian than Roman in its facades, for by the time Holland came to work on the house, the influence of Greece was superseding the strong hold that Rome had on men like Adam. The long low ranges are subtly under stated. The detailing is purer and more restrained than at Kedleston. Inside the house has an altogether more intimate air, partly because it is not so grand a design, but also because this was more in line with the wishes of the patron. However, the richness and opulence of which the Neoclassical designer was capable are evident in the drawing room, where great imperial eagles soar and plunge over the windows catching the folds of the pelmets in their beaks. Gilded and convincingly predatory these Roman imperial birds lose nothing of their grandeur by being transplanted to the drawing room windows. In Mrs Whitbread's boudoir a less dramatic but no less opulent scheme of decoration was executed by Louis André Delabrière, a French architect and decorator.

Kedleston and Southill exemplify the transition from Roman to Grecian influence in British architecture, but also give a clear idea of how the splendours captured by architects in their drawings and published portfolios were translated into symbols of power and prestige in the British countryside.

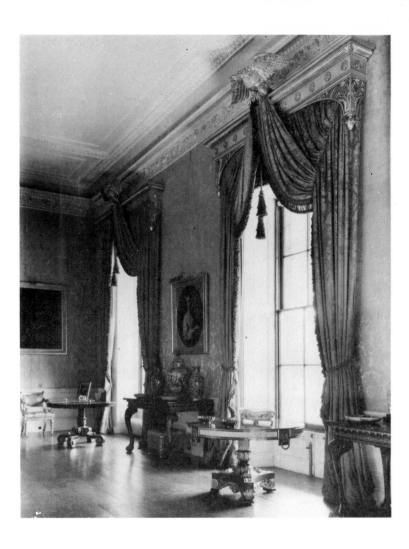

Southill, Bedfordshire,
the drawing room.

THE GREEK IDEAL

Just as Piranesi and others had formed for the whole of Europe
a mental picture of Rome, so Johann Joachim Winckelmann
created an ideal image of Greece. Winckelmann was a German
priest and scholar, whose ruling passion was for Greek statuary,
but who never visited Greece, and only knew the statues he wor-
shipped in Roman copies, many of which were inferior or badly
restored. In his book, *On the imitation of the Painting and Sculpture
of the Greeks*, written in 1755 before he had even seen Rome,
Winckelmann wrote: 'There is only one way for the moderns to
become great and perhaps unequalled: I mean by imitating the
ancients.' This is basically the same idea that Piranesi made effec-
tive in his drawings of ruins.

48

But Winckelmann is different from Piranesi, not only because he fell under the spell of Greece rather than Rome, but because his love was for statuary rather than architecture. He wrote on the perfection and dignity of the human form as idealised in sculpture, and he published studies of individual works, such as the *Apollo Belvedere* in the Vatican. It almost seems that Winckelmann avoided visiting Greece itself perhaps because he feared to expose his dream to the light of reality. Certainly it is true that for him Greece and its art remained finally an idea, rather than a reality, and also an ideal. There is no objectivity in Winckelmann's classicism, least of all in his devotion to classical anatomy. His admiration for statues like the Apollo was based on a yearning for the ancient Greek culture not only in terms of its art but as the possible setting for an impossible love. Winckelmann is a sad figure. He was murdered at the height of his career by a thief, with whom he may have been involved sexually, who stole from his body medals awarded by the Empress of Austria for his services to scholarship. But though he was, like Piranesi, a difficult and sad man, Winckelmann was one of a group of highly influential artists and theoreticians among whom was the leading classical painter of the day, Anton Raphael Mengs.

NEOCLASSICAL PAINTING

Mengs had come to Rome from Dresden, one of the strongholds of Rococo painting and architecture in Europe. He was not initially in the least an austere or classical artist, but he became, under the patronage of Cardinal Albani, who also employed and encouraged Winckelmann, a pure and often over-academic artist. His devotion to the classical ideal is enshrined in his *Parnassus* executed for the ceiling of Albani's villa. This is academic art for the academics. The message is a flattering one intended for the Cardinal himself. The subject of Apollo and the Muses often recurred in ancient art. Parnassus was the home of the Muses who, in Greek mythology, inspired the various forms of art, painting, architecture, music, history. Apollo is the God of the Arts, and protector of the Muses. The implication, which is neat and not unduly empha-

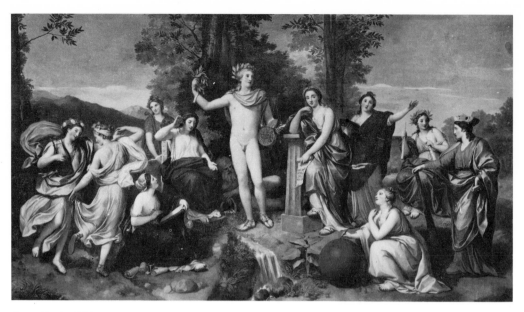

Anton Raphael Mengs, *Parnassus*, 1761, ceiling decoration, Villa Albani, Rome.

sised, is that when Cardinal Albani looks up at his modern Parnassus on the ceiling, he, as a modern Apollo, is looking at his own mythical counterpart. Albani certainly acted as a protector to both Mengs and Winckelmann, allowing them to explore their ideas thoroughly in a sympathetic atmosphere. But the very purity of the ideas discussed and the austerity of the style in painting differentiate both artists and theorists from many of their contemporaries: for this is rarified intellectual art, before it has been popularised for the majority. The smooth and finished surface of the work is the visible manifestation of a desire to unite all elements in the picture into a harmonious whole. The restraint of gesture indicates that Roman dignity, that Greek grace, which was the aim of the classical painter.

Of all the painters of the eighteenth century Mengs was perhaps internationally the most influential. Many artists at Rome admired and emulated him, international society feted and patronised him. However, one of the clearest and purest records of an artist's commitment to the classical ideal is to be found in the writings of an Englishman, the contemporary and rival of Gainsborough, Sir Joshua Reynolds. Reynolds fulfilled all the requirements of a classical academic training. He studied under Thomas Hudson, the English portrait painter, before travelling to Rome to copy anatomy from the antique, and fine painting from the great masters of the High Renaissance. The pantheon of works of art by Raphael and his contemporaries with which

Zoffany filled the painting of the *Tribuna of the Uffizi* (p. 8) might stand as a roll-call of Reynolds' masters. Reynolds was not only a painter but a fine critical writer on the arts. He helped found the Royal Academy in 1769, thus giving England its counterpart to the earlier Royal Academy of Painting and Sculpture founded in Paris in 1648. Each year, as president, he lectured to the students training in the fine arts, and these discourses form the fullest explanation of the Neoclassical theory of art that has been written. An indication of their importance is the speed with which translations appeared in French, German and Italian. In splendid rolling passages he analyses the history of art and its application to the study of a modern painter. Of the ideal beauty which should be the object of all art he wrote:

'The Art which we profess has beauty for its object; this it is our business to discover and to express; but the beauty of which we are in quest is general and intellectual; it is an idea that subsists only in the mind; the sight never beheld it, nor has the hand expressed it; it is an idea residing in the breast of the artist, which he is always labouring to impart, and which he dies at last without imparting; but which he is yet so far able to communicate, as to raise the thoughts, and extend the views of the spectator.'

This grand and platonic vision of art, as something capable of influencing people for positive good is the highest realisation of the Neoclassical vision. In visual terms it can be understood in Reynolds' magnificent *Mrs Siddons as the Tragic Muse*. Here Reynolds has taken the essence of a likeness and invested it with a majesty and drama worthy of the greatest actress of the age.

When Gainsborough painted the actress a year later, he portrayed an acute and elegant woman of the world, and did nothing to disguise her long and equally acute nose. One artist has captured the sitter as it were in her street clothes, the other has expressed an idea of drama, 'an idea that exists only in the mind; the sight never beheld it, nor has the hand expressed it', and comes closer to an understanding of why this angular and quizzical woman was the doyenne of the London stage. He has also rung up the curtain on a scene of impending doom, the hemlock held at the Muse's elbow, the sorrow of inevitable waste hanging over the seated figure.

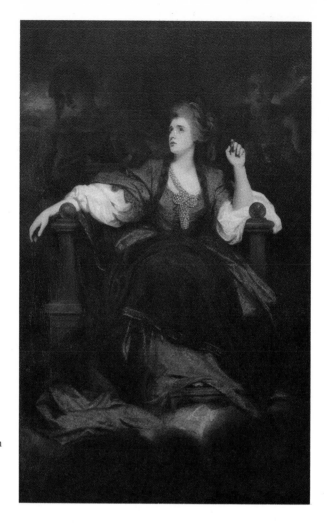

Sir Joshua Reynolds,
*Mrs Siddons as the
Tragic Muse*, 1784, oil on
canvas, 236 × 146 cm,
Henry E. Huntington
Library & Art Gallery,
San Marino, California.

There is in the picture much for the trained eye and the informed
mind. Reynolds' contemporaries would have recognised the source
for Mrs Siddons' pose as that of the Sibyls in Michelangelo's
frescoes on the Sistine ceiling. The allusion to the Muse
would not be lost on those familiar with ancient literature.

This universal language of the arts was, of course, limited to
the educated classes. The dilettanti of the *Tribuna of the Uffizi*
would have understood perfectly Reynolds' intentions. Below the
educated middle classes, such sophistication went for nothing. Yet
the pure flame of knowledge should, critics and scholars reasoned,
be available, as in ancient Greece, to all. It has already been
shown that a rich source of inspiration was the gentleman's library.
But a gentleman's library was private. Academies of art such as the
Académie Française, the Royal Academy and the Accademia di San

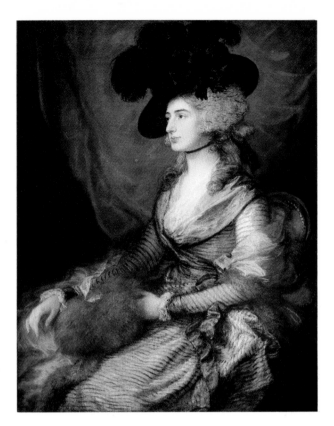

Thomas Gainsborough, *Mrs Siddons*, 1785, oil on canvas, 126 × 98 cm, National Gallery, London.

Luca were highly valued by artists and architects throughout Europe because they provided a professional framework for tuition in the theory of art. What remained for those eager to be uplifted, enriched, improved not only spiritually but morally by the experience of the ancient world? For these, the answer, in the next century, was to be museums: literally, homes of the Muses who sat at Apollo's feet, one of whose number Mrs Siddons represents.

The idea of art for the public grew in importance and acceptance throughout the eighteenth century. The aristocratic and royal patronage which had encouraged most artistic activity, had also concentrated the finest collections in the hands of a few collectors. Access to palaces and great houses was limited at the start of the century, though it became more widespread as time went on. Visits to country houses in England to see the fine collections of old-master paintings, visits conducted usually by the butler or house-keeper, became almost as general a feature of eighteenth-century tourism as they are today. In Italy travellers went to the Vatican in Rome and the Uffizi and Pitti palaces in Florence. Watteau, it will be remembered, was able, while studying under Audran, to

53

copy the Marie de' Medici cycle of paintings in the Luxembourg Palace.

However, classical taste and Neoclassical intellectual preoccupations called for something more nearly purpose-built than these cabinets of royal pictures, or assemblages of aristocratic taste. Just as there was a precise formula for study of the arts, so there must be a carefully planned home for the products of that study. The museum as we know it today was born. The new type of building presented problems, but to Neoclassical architects there was one great exemplar from which to draw their plans. The temples of Greece and Rome had contained statues of the gods, to be worshipped in pagan rites. Now these same statues should be housed in new temples devoted to worship of pure beauty. It was in many ways the realisation in academic terms of Winckelmann's dream of an Arcadian world in which perfection of form should rule supreme.

All the greatest examples of museum architecture lie strictly outside the eighteenth century, but all belong in important ways to the aesthetic pursuits and demands of that century. Leo von Klenze's Glyptotek in Munich was designed as the first purpose-built gallery for the display of classical statuary in 1816. Klenze led the way for other architects. The German states were particularly fertile ground for the growth of public building design.

A sense of civic and political pride caused each Prince or Elector to outdo his fellow-monarchs in his espousal of Winckelmann's principles. Prussia, as the foremost of the German states, benefited more thoroughly than most from this concern with public building. Karl Gotthard Langhans was architect to Frederick William II of Prussia. His Brandenburg Gate, at the end of the great formal avenue, Unten den Linden, is directly derived from Greek Doric architecture. It ushered in Prussian Neoclassicism, of which Schinkel was a major exponent.

Karl Friedrich Schinkel effected a complete transformation of the centre of Berlin, making one of its most important features the Altes Museum, the museum of ancient art, a new and monumental public palace intended to house the Royal Family's art collection. Here, behind the temple-like range of massive columns, exciting and dynamic diagonals are created by the great open staircase. The

Karl Gothard Langhans,
The Brandenburg Gate,
Berlin, 1788–91.

public approaching this new shrine of art, replete with trophies of
the ancient civilisations, saw around them and below, a strictly
planned city, embracing public ministries, royal palaces, barracks
and every other manifestation of a highly ordered society. Behind
the regimented militarism lurked less controlled and less amenable
ideas, a self-dramatising and emotive force which had been con-
stantly present in the development of classical art throughout the
century (see p. 31 and p. 36). The impact of individualism was
already strongly felt when Schinkel created his great new city
centre. The forces of a new, romantic movement were already
engaging the leading minds of Europe.

55

4 The garden and nature

THE EARLY EIGHTEENTH-CENTURY GARDEN

A garden is not a part of nature. It is man's reordering of nature along lines which reflect his own preoccupations and theories. The word nature had in the eighteenth century a variety of meanings, some very different from what we understand by the word today. In Jane Austen's novel *Emma*, for example, Mrs Elton, the vicar's wife, encounters opposition to her plans for a picnic of great elaboration and painstaking effect. She seeks to conjure up a rural idyll with the company gathering strawberries in ribboned baskets:

'There is to be no form or parade – a sort of gypsy party. We are to walk about your gardens, and gather the strawberries ourselves, and sit under trees; and whatever else you may like to provide, it is to be all set out of doors – a table spread in the shade you know – everything as natural and simple as possible. Is not that your idea?'

Mr Knightley, the squire, and unwilling host, counters:

'Not quite. My idea of the simple and natural will be to have the table spread in the dining-room. The nature of gentlemen and ladies, with their servants and furniture, I think is best observed by meals within doors.'

This is a confrontation between the formal, 'classical', view of society and the hunger of the romantic for an ultimately absurd and unreal ideal. Mrs Elton yearns for a pastoral life, supposedly natural, but only to be achieved with conscious artifice. There is as much artifice in her ribboned baskets as in Mr Knightley's dining-room. Whether nature should be tamed or not, was a problem. In fact all approaches to nature involved some degree of artifice.

In the seventeenth century gardens had been rigidly ordered patterns of plants, walks and decorative statuary. They formed part of the architectural setting of a palace like Versailles. They were also carefully distinguished from parks and farms, which

Claude Lorraine,
*Landscape: Cephalus and
Procris reunited by Diana*,
1645, canvas, 102 × 132 cm,
National Gallery,
London.

were for the hunting of animals and the cultivation of crops. People were interested in nature for its plants, but not for any accidental beauty of landscape. The first suggestion that something in a landscape could in itself be worthy of preservation as an attractive feature came from the English architect Sir John Vanbrugh. When in 1705–25 he was building the palace of Blenheim, in Oxfordshire, for the Duke of Marlborough he wrote that Woodstock Castle in the park should be preserved for its charm and historic interest. It made an element in a composition in the landscape, and was in this respect like an element in a painting. It was, in Italian, *pittoresco*, picture-like, and from that derives the word picturesque. That is what Vanbrugh meant though he would not himself have thought to use that word.

What sort of picture was it that the old castle resembled? Chiefly the landscape compositions of Claude Lorraine, the French seventeenth-century artist. His views, supposedly of scenes in the Roman *campagna* or countryside, hung in many English country houses. In these pictures the buildings are classical towers and

57

Woodstock Castle,
Oxfordshire, in 1714.

ruins. Vanbrugh wished to preserve a ruined castle, but the idea of a
building as an eye-catcher in a landscape is identical. In a painting
or a park it was equally possible to mould nature to the artist's
ends. The pictures were a standard against which to measure
nature. But nature unaided rarely came up to the mark. Claude
himself had helped nature by selecting elements from different
scenes to make up one composition. It was only a short leap for
the imaginations of gardeners, architects and patrons to apply this
principle of selection in art to the creation of parks and gardens.
This was the starting point for the development of a theory of the
picturesque. Where there were no associative or historic buildings
to catch the eye, then these must be designed. Where no water ran,
channels must be dug; hills must be raised and valleys sunk. Nature
was to be rehabilitated in the image of art. The formality of great
walks and flower-beds was to be broken up in an apparently hap-
hazard but in fact carefully planned manner. This approach to
gardening is 'classical' for, like classical painting, it calls for an
ideal beauty. It suited well the needs of patrons like Lord
Burlington, whose charming villa at Chiswick, outside London,
epitomises the graceful formality of the houses around which these
gardens were planned, houses which are Palladian, from the origin
of their designs in the work of Andrea Palladio, a sixteenth-century
Italian architect.

Palladio had published in 1570 his *Four Books of Architecture*, in
which he recorded complete reconstructions of ancient buildings

58

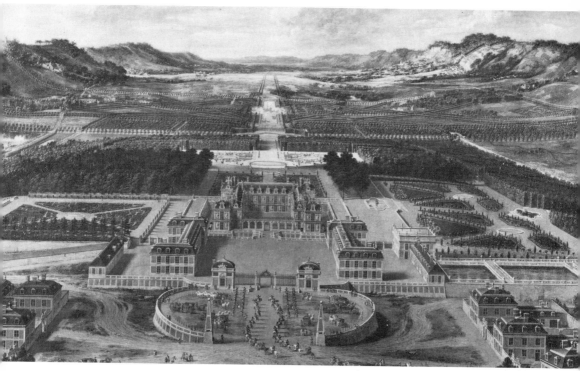

J. B. Martin, Versailles,
the palace and formal
gardens.

and the detail of ancient architecture. It was a pattern book of the
greatest importance and many English houses were based on it.
Some of these buildings were huge and grand, others, like Chiswick
House were little more than charming pavilions. Palladio's own
villas were often intended chiefly as summer retreats, such as the
Villa Rotonda, on which much of the design for Chiswick was
based. Palladian design was therefore well adapted to the creation
of garden buildings, nestling among trees or prominent on a dis-
tant hill, whose chief purpose was to please the eye. Lord
Burlington was chiefly responsible for popularising the style hav-
ing been fascinated by Palladio's work when he made his grand
tour. Burlington himself designed buildings and was an influential
patron. William Kent, the painter and architect, was Burlington's
protege and, with the literary support of men like Alexander Pope,
the poet, Burlington and his circle proselytised England with the
Palladian style.

Pope addressed to Burlington a verse epistle on the subject of
taste. This elusive quality, so prized in the eighteenth century
called for instinctive sensitivity, but might be cultivated by the
advice of the finest minds. Such a mind, Pope states, is
Burlington's. He goes on to mock those who create formal par-

59

George Lambert
(attrib.), *Chiswick House*,
1742, pen and grey wash
over pencil,
32.4 × 53.7 cm.

terres, or flower-beds, like those of the French garden designer Le Nôtre.

> No pleasing intricacies intervene
> No artful wilderness to perplex the scene;
> Grove nods to Grove, each alley has a brother,
> And half the platform just reflects the other.

In place of this tedious repetition Pope recommends the calculated naturalness of a landscape like that at the great country house of Lord Cobham – Stowe in Buckinghamshire. When Pope knew Stowe, the original planting had been modified by Charles Bridgeman, the garden designer, and William Kent. The effect was of a landscape which had grown up by accident, in which temples and lakes were scattered by chance and history. Kent's Temple of Venus, seen across water, is an image of the ancient ideal world. It was originally intended to be backed by massing trees, so that all the colour of the park was in tones of green; flowers and varied colours had no place in this restrained world. Visitors to Stowe were meant to walk along paths that led them from one building to another, then on through trees and over water, so that unexpected vistas opened up of garden buildings, perhaps already seen, but now transformed by distance or setting into a new creation. Reflections multiplied these temples until it was impossible to say how many there were. The circular tour, giving a false impression of scale and distance, was an important device in such landscaping.

60

William Kent, Temple
of Venus, Stowe, 1797.

William Kent, Temple
of Ancient Virtue,
Stowe, *c*.1735.

Stowe was not merely a pleasure ground. Lord Cobham was a
radical statesman, and many of the statues in the grounds refer to
contemporary politics or ancient ideals. In Kent's Temple of
Ancient Virtue and Gibbs' Temple of Friendship there are busts
of philosophers, poets (including one of Pope himself) and artists.
Inigo Jones, the court architect of Charles I, had begun the search
for Greek and Roman classical prototypes to copy in English archi-
tecture, and is therefore honoured by a bust. This garden is as
much a literary as a visual landscape, a landscape of ideas. Here the
men and women who formed the important artistic and intellec-
tual circles of the day can be seen self-consciously preoccupied
with the philosophy they espoused. Nature has little true part in
this close-knit sophisticated world, with its allusions to Claude,
classical theory, politics and philosophical speculation. Yet it was
more natural than earlier gardens.

61

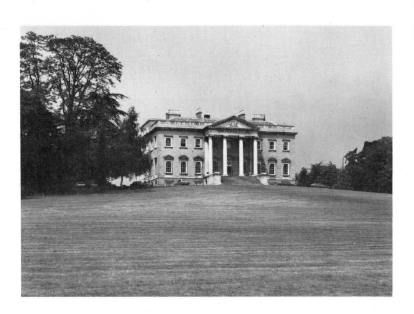

Capability Brown,
Grounds of Claremont
House, 1770s.

At Stowe, as in Claude's paintings, it was possible to believe oneself in another, an ideal world. The next step in the creation of the artificially natural garden was the evocation of a landscape which seemed at first glance to be wholly recognisable as the world of every day. The most famous landscape gardener in England created landscapes which apparently had grown entirely by chance, but in fact owed everything to thoughtful planning. Capability Brown brought the distant countryside to the doors of his patrons. Whereas the landscape at Stowe was still divided into the formal naturalism of the garden and the practical landscape of the park, Brown brought lawns and trees up to the house. At Claremont House (near Esher in Surrey) the approaches for the service drive are buried in tunnels so that no passing butcher or saddler could destroy the illusion of open country which the owners enjoy. The planting of trees mimics nature in its haphazard arrangement. Modern ideas of what constitutes the 'English land-scape' owe more to Brown than anyone, including nature. He extended the use of water, making wider, freer forms with it, dom-inating a landscape composition with a lake, as he did at Blenheim when remodelling Vanbrugh's earlier designs.

The renovation and modification of such gardens makes the historical study of garden design particularly difficult. Apart from the difficulty of deciding who originally planted a wood or dug a pond, there are the inevitable changes brought about by time and climate. Ironically enough, the patrons who commissioned these gardens rarely saw more than a shadow of the intended effect. Two

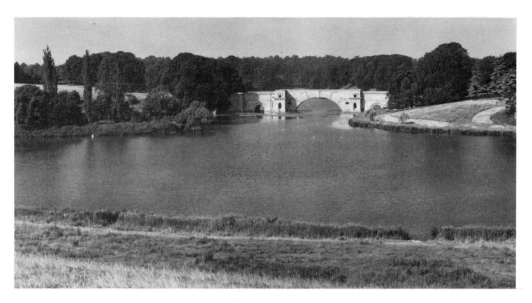

Blenheim Palace, the lake showing Capability Brown's planting, 1764–74.

hundred years later we are more able than the original owners to appreciate the intentions of Kent at Stowe or Brown at Claremont. Brown's coppices now seem embedded in the landscape. Long rides shaded by broad oaks with water glinting somewhere in the distance characterise the English landscape. It is only when one examines the buildings which were put in those landscapes that the extent to which artistic appreciation and critical theory influenced men's intentions in landscape gardening becomes fully apparent.

CHINOISERIE AND CLASSICAL RUINS

Garden buildings have the advantage over public or domestic architecture that they are less expensive to erect and less liable, if they prove an aesthetic disaster, to be taken too seriously. They are therefore often the most remarkable manifestations of personal taste in eighteenth-century architecture. While Rococo architecture took firm hold on exterior design only in Germany and Austria, it emerged in England and France in the form of mad and apparently impossible designs for garden buildings. While Stowe was being built Frederick, Prince of Wales, the son of George II, was creating at Kew a garden along similar lines (these were the ancestors of the present Botanic Gardens). He laid out the general scheme of water and planting before his early death. Chambers had already executed various ornamental pavilions for

Sir William Chambers, pagoda, Kew, built 1761. Engraving by William Woollett, Victoria and Albert Museum, London.

the prince, but under the patronage of the prince's widow he went on to create ever more unlikely and delightful ornaments. The best preserved and most astonishing is the pagoda at Kew.

A pagoda in Middlesex is an unlikely idea in the first place. The desire for a Chinese temple in one's park is irrational, frivolous and delightful. China was an unimaginably distant and mysterious land. Unlike Rome, which was associated with important and influential ideas of government and art, China, the ancient and colourful civilisation of Cathay, was so far removed from certain knowledge or immediate experience that the architect's imagination might rove over the idea of a pagoda, or a Chinaman or a Chinese landscape without fear of offending propriety or transgressing a rule. With this free rein, Chinoiserie comes close to the spirit of Rococo, and Rococo motifs often therefore appear in the unlikely guise of Chinese decorations. The pagoda at Kew rears up in the rustic landscape without excuse or explanation. It is an object of curiosity. Chambers claimed to have authentic examples of Chinese architecture before him in designing it, but much of the detailing is fanciful. The curling roofs and gilded finials; the cav-

Maison Chinoise, Désert de Retz, Seine-et-Oise, France, 1785. Engraving from Le Rouge, *Détails des Nouveaux Jardins* vol. 13.

orting dragons, each of which originally held out to the passing wind chimes of golden bells; also the fine fretwork of the balconies; all owe much to Rococo taste. Tea, which was the exotic fashion craze at the time, might be drunk in the shade of this folly. One might pretend one was in China and, as the bells played, imagine obscure and pleasantly frightening religious rituals being enacted within the temple. It was possible to ally the real world to an imagined and exciting extension of life in dreams and fantasies, just as the French court had done with Watteau's paintings.

The Chinese taste was an extreme fashion. It developed first in the 1720s and flourished throughout the century. In France there was a vogue equal to that in England, and Chinese houses appear in numerous of the so-called *jardins anglo-Chinoise*. These gardens followed the English pattern of a winding path leading from one view or building to another. There was if anything greater emphasis on the associative ideas attaching to each building, so that the spectator might pass from one to the other as if following a menu of thought and association. The finest of these parks was the Désert de Retz, which had its own *Maison Chinoise*, gilded and painted and, in prints, fitted out with an attendant mandarin. Alongside this pretty conceit there was also a unique and astonishing building, which heralds a theme of great importance in the idea of the garden.

The Column House at the Désert de Retz is conceived on a scale of grandeur to match anything of Piranesi's. It is a four-storey house in the form of a gigantic fluted column broken off at half height. It is brick-built, plastered, and has oval windows, like portholes in its sides. As architecture it is more than a little absurd. Certainly practical considerations were not uppermost in the mind of Monsieur de Monville, who commissioned the building. What

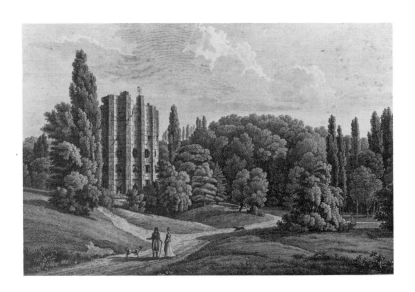

Column House, Désert
de Retz, Seine-et-Oise,
France, 1780–1.

is breathtaking is the scale of the idea behind the structure. If this
is a column broken off short, then at some time it must have risen
to a greater height. The imagination, grasping this, restores the
original scale of the column, and from it infers the previous exist-
ence of some structure of which it was an integral part. There was
perhaps a temple or tomb, the palace surely of a Titan emperor or
the pavilion of a Colossus. The scale soars now to almost unim-
aginable height and breadth. The absence of any capital frees one
of all limitations. Before such a vision man is cowed, dwarfed
and subjected to the realisation of his infinitesimal insignificance.

Such ideas did not necessarily always occur to de Monville and
his friends whenever they looked at the eccentric Column House.
But such ideas did lie behind the concept of such ruins and follies.
They indicate a less rational approach to the world. Man becomes
powerless against the scale of his surroundings and there is in
that sense of powerlessness a pleasing thrill of fear. The reason
and harmony which inform the garden world of Pope and Burling-
ton, in which man is the natural measure of all things, are replaced
by a dramatic and uncontrolled violence in both nature and man.
This is the darker side of the theory of the picturesque.

THE GOTHIC STYLE

The landscape of ideas which was created in gardens like that at
Stowe had already something of the drama which addicts of the
picturesque were more and more to seek. People paid 'hermits' or

above: Two ladies
visiting a Hermit,
Private collection.

above right: William
Kent (attrib.), *Pope in his
grotto*, *c.*1725–30, pen
ink and wash,
22 × 19 cm, Devonshire
Collection, Chatsworth
House, Derbyshire.

supposed 'monks' to sit in garden ruins and temples, withdrawn
from the world in contemplation. Thus when showing one's gar-
den to friends, a visit to the hermit in his grotto was a dramatic
diversion, and the grotto itself, set among rocks, by water, or in a
hillside, became an essential feature of garden architecture. Pope
himself had one at his villa at Twickenham, near London, to
which he would withdraw to seek inspiration for his poems.

Near to Pope's riverside villa Horace Walpole, writer and dilet-
tante created a house which, although he lived in it, was to be the
most influential folly erected in England in the eighteenth-century.
Walpole's interests were not bounded by picture-collecting on the
Grand Tour or by the excavations at Pompeii and Herculaneum.
At Strawberry Hill he created, from 1747 onwards, the most
famous Gothic building of the age. Although it began life as a sim-
ple villa, Strawberry Hill became in the course of fifty years a
complete statement of the development of picturesque theory in
England. Walpole's idea of a sham castle to house his collections
was inspired partly by the fashionable enthusiasm for collecting
and museum-making. Despite the increased interest in Roman and
Greek ruins, shared by Walpole, there also was a strong under-
current of enthusiasm in England and France for medieval
remains, not least because of their picturesque associations.

The house was built piecemeal over many years. It was impos-
sible to plan, and Walpole turned this disadvantage into a virtue.

67

Thomas Rowlandson, *Strawberry Hill* (Twickenham, Middlesex), *c*.1790, watercolour, pen and pencil on paper, 24 × 38.8 cm, Victoria and Albert Museum, London.

The original gothicising was no more than a thin skin cloaking a classical villa. The Gothic style is of course a structural style. Pillars, vaults and arches express in their form the way in which the building was put up. Walpole however, used Gothic detailing as a decoration, and this style is often called 'Gothick', as this was the eighteenth-century spelling. The east front of Strawberry Hill was always symmetrical, and despite its pointed windows and Gothic details was never awe-inspiring or dramatically composed. Later Walpole added a north front ending in a circular tower. The tower, emerging from the trees, resembles a story-book fortress. The effect is close to that achieved in Claude's pictures, where small castles appear above the woods, but there is also something of the traditional English castle about it. Walpole was himself a man of classical more than romantic sensibility. Seated in his library he would have delighted in the idea rather than have been oppressed by the terrors of a Gothic world. But there was a growing devotion to such horrors in the reading public, and Walpole's own novel, *The Castle of Otranto*, was a great popular success, evoking a world in which helpless virgins are under constant threat from the attentions of mad monks, or aristocrats posing as mad monks. The Gothic novel as much as the Gothic building created the fantasy world which so appealed to Walpole's contemporaries. The drama of a gloomy and ruinous midnight world patrolled by ominous

68

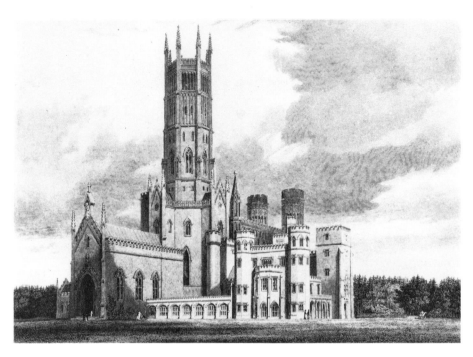

Engraving of James Wyatt, Fonthill Abbey, south-west view, before its collapse, taken from *Graphical and Literary illustrations of Fonthill Abbey, Wiltshire* by John Britton, 1823.

religious figures was as pleasing to the reader as any evocation in architectural folios of Roman splendour and might.

Collapse and decay were as assiduously cultivated by devotees of the Gothic style as they were by Neoclassical enthusiasts. It is therefore the more fitting that the most remarkable eighteenth-century Gothic Revival building created, Fonthill Abbey in Wiltshire, should have exceeded the wildest expectations of its owner, William Beckford, by collapsing within twenty-five years of its creation. Strawberry Hill was the source and model for Gothic buildings throughout Europe, but Fonthill was the spectacular infamous wonder of its day. Beckford was, like Walpole, a connoisseur of art and antiquities. His home was a museum, but also a retreat, for unlike the socially sought-after Walpole, Beckford became a social outcast by extending his passions beyond collecting to self-indulgence and flagrant sexual excess. He was ostracised by society, and willingly adopted the pose of the lone figure, the eccentric 'Gothick' hero, outfacing convention and the world. His nerve in everything was breathtaking, but nowhere more so than in the scale of Fonthill. Despite the soaring tower and arching halls of the abbey, Fonthill resembled nothing so much as a garden building in the frivolity and recklessness with which it was thrown up. Neither Beckford nor his architect James Wyatt planned the undertaking with any degree of seriousness. Beckford

wanted to realise his dream as soon as he had conceived it, and
Wyatt achieved impossible deadlines by shoddy work and skimp-
ing on structural support. The central tower, the folly, served no
useful purpose and, weaker than any other part of the whole, col-
lapsed on its meagre foundations, destroying the surrounding
wings. Perhaps if he had actually been able to watch the annihila-
tion of his fantasy Beckford would have considered his money
well-spent. The ruination of Fonthill came nearer than any other
event to realising an ideal pursued by architects and connoisseurs
throughout the age: the decay of a dream almost as it was con-
ceived.

NASH AND REPTON: THE FINAL PHASE OF THE PICTURESQUE

Houses like Strawberry Hill and Fonthill were the innovative mas-
terpieces upon which many humbler houses were modelled. These
castellated and carefully asymmetrical designs stood neither in the
elaborately effortless landscape of a Stowe, nor in the ideal English
landscape of Capability Brown. Their gardens were more dramatic,
more apparently natural, since accidents of nature were more fully
exploited and existing elements like quarries might be incorpor-
ated for dramatic effect. Yet these landscapes had evolved from an
ideal which owed much to Claude, and presented to the onlooker
an image of the natural world rather than its reality. Humphry
Repton sought in his garden designs to convey the 'true character
of place' in the improvement of a site. Ironically one of his most
important surviving achievements was the creation of a park
where there had been no true character before, and the evocation,
in the centre of a great city, of the ideal countryside. In conjunction
with the architect John Nash, Repton remodelled the area of
London now called Regent's Park, producing an alliance of street
and garden design. This was conceived as a triumphal way from
the Prince Regent's palace, Carlton House, to the newly built and
planted park, over which a great summer palace for the Prince
should look. The summer palace was never built, but the stun-
ning streets convey today an impression of imperial power and

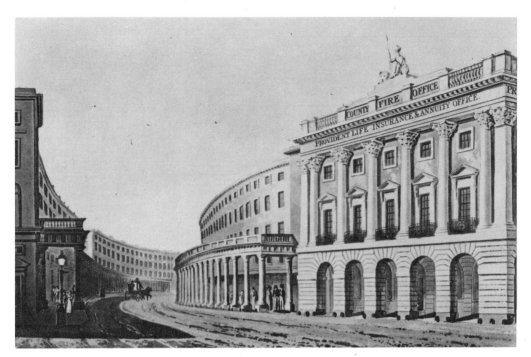

John Nash, Regent
Street (*top*) and
Cumberland Terrace.

dynastic glory as dramatic as any scheme of town planning in
Europe. There is an alliance of Neoclassical grandeur and pictur-
esque grace which draws on the experiments of the whole
eighteenth century. Nash's original quadrant in Regent Street,
now destroyed, was a perfect balance of classical restraint and
dramatic ebullience. Block after block, the Nash terraces led up to
the casual but artful planting of the park, hiding yet revealing
among the trees villas from a world that harks back to Claude.
A sprawling, irregular lake gives light and vivacity to the great
palatial terraces surrounding the park, built of brick and stucco
rather than stone. For there is something of the quality of a stage

71

John Nash, Blaise
Hamlet, near Bristol,
1809.

set in this scheme. The gleaming facades, gilded and bedizened
with statuary, make their effect from a distance.

When seen close to, the cardboard two-dimensional impression
of the architecture is even stronger, for architraves lack comple-
mentary roofs, and windows, apparently lighting great drawing
rooms, give onto cramped and badly planned houses, forced into
strange corners by the requirements of the formal facade. The play-
acting which was so important to eighteenth-century men and
women reached its apogee in the last years of that century. The
formal rule of taste gave way to enthusiasms for exotic and lavish
spectacles: the carnivals of Venice, the pomp of Napoleonic Paris,
the gilded social extravagance of the Prince Regent's London.
Even the greenery of Regent's Park is not natural, but ordered to
a preconceived idea. It is a *rus in urbe*, a paradoxical countryside
transported to the city, and as such a hybrid creation.

Even when, at Blaise Hamlet, a village near Bristol, Nash was
able to design a group of workers' cottages for a patron, he created
not a contemporary exercise in village planning and practical
country architecture, but the manicured and cosmetic image of

Mique, Le Hameau,
Versailles, begun 1783.

every Englishman's idea of a village. Thatch so impossibly curvaceous resembles an overstuffed *chaise longue*, and the tiny lattice windows seem crushed beneath such a weight of roof. This group of houses is as charming and unreal in its affectation of nature as was Mrs Elton's proposed picnic.

Such travesties are not of course necessarily harmful or wrong. They can be amusing and rewarding creations. But in France, Le Hameau, a mock farm created in the park at Versailles for Marie Antoinette, queen of Louis XVI, symbolised a misunderstanding of true rural life, an indifference to the hardships beyond palace gates and park palings, which was to lead to disaster.

73

5 Revolution and art

The Royal Family of France remained, from the time of Watteau until the collapse of the monarchy in 1789, loyal to the Rococo style in painting. Both Louis XVI and his wife, Marie Antoinette, were munificent patrons of the arts. They encouraged painters like Fragonard and their reign is still famous for furniture and interior decoration that has never been surpassed. But they lacked the political perception to see that real grievances of the labouring peasantry were also reaching a dangerous pitch and winning support from those enlightened middle-class intellectuals who thought they could control a limited revolution. These included men like Robespierre who thought that through education they could create a new social order, and make revolution constructive; violence would be justified by the need to destroy a greater political evil. But the violence, once unleashed, overwhelmed such idealism.

In the revolution that broke out in 1789 little distinction was made between individuals. Class hatred exacted an appalling retribution from the aristocracy and then, increasingly, from all who stood in the way of those controlling trials and executions. The old balance of power, based on a tacit agreement between the aristocracy and the king, and underpinned financially by rich middle-class bankers, had been upset, and those who had acquiesed in the fall of the monarchy became the so-called 'Terror's' next victims. The whole edifice of the French court collapsed, and painters and sculptors who had trained under the *ancien régime* (as it is now called) were faced with a different political structure, and with new propagandist demands. Of course there were elements of continuity. Many of the new generation had trained with the painters of the Watteau school, and themes from the classical world could still be used for the expression of ideas. But the ideas were new and the ideal world which the revolution sought to create

J. L. David, *The Intervention of the Sabine Women*, 1798–9, oil on canvas, 385 × 522 cm, Louvre, Paris.

was very different. Some artists responded with delight to the new revolutionary freedoms. One of these was Jacques-Louis David.

Jacques-Louis David began his career in the studio of Vien, a follower and distant cousin of Boucher, Madame de Pompadour's protégé. From there David travelled to Rome where he underwent the transformation which the phenomenon of Rome and the theories of Winckelmann produced in most able and enquiring students. He returned to France a resolute classicist and became at the Revolution the propagandist and image-maker of the new political regime. But his art represents a more humane and moderate outlook.

His *Intervention of the Sabine Women*, depicting an incident from ancient Roman history, reveals this attitude. For all its classical allusions the picture could well be a dramatisation in ancient dress of the storming of the Bastille, the State prison whose fall marked the beginning of the Revolution proper. The intervening female figure could stand then for a noble and merciful France, restraining the excesses of the revolutionary terror. When the first Directory, or revolutionary committee, was formed there was an orgy of revenge for two centuries of indifference to and repression

75

of the people. Men like David felt that this was unjustified, and destructive not only of the society which had gone before but of the new egalitarianism as well. The *Intervention* tells how the Sabine women, after being abducted and raped, prevented their men from exacting full revenge on Rome for their humiliation. It relies heavily on the poses of classical statuary for the grandiose gestures and ideal physique of the combatants. It is of course unlikely that the Sabine men went into battle naked and without armour. But the picture is more concerned with conveying a sense of nobility and ancient virtue, the virtue especially of mercy, than with historical accuracy.

One of the reasons why David adopted the Neoclassical style so readily was that it was in accord with his own ideals. The revolutionaries in turn adopted him as their propagandist because his alliance of classical art and high moral values were well suited to express their political theory. Just as the Roman Senate had defended the purity of Roman democracy against the Caesars' dictatorship, so the Directory would protect and restore the ancient and natural right to democracy of the French people. Nature, too, was adopted by the revolutionaries as a guiding principle. Theirs was again the nature of an ancient and mainly imaginary civilisation, in which the dignity of manual labour had not yet been eroded by sophistication and idleness. Despite this picture of the classical world being scarcely more credible than that depicted by artists, architects and gardeners for the last hundred years, the natural law was a banner to which all could gather.

THE INDUSTRIAL REVOLUTION

Britain did not suffer a political revolution. The powers of the monarchy had been limited since the Civil War in the seventeenth century. While France, which remained a chiefly agricultural nation, underwent a violent and destructive social upheaval, Britain experienced a change of a different but no less profound nature. This change, now known as the Industrial Revolution, occurred in part because of the discovery of new materials and new scientific inventions. Coal offered new means of powering

Philip James de
Loutherbourg,
Coalbrookdale at Night,
1801, oil on canvas,
68 × 106.7 cm, Science
Museum, London.

machines, and the inventive brilliance of men like James Watt,
who created the steam engine, and James Arkwright, whose new
looms revolutionised cotton weaving, presented efficient solutions
to an uprush in demand for goods. Britain had acquired an over-
seas empire which provided new markets for manufactured goods.
Businessmen grasped the new opportunities. Artists were equally
inspired by this buoyant and innovative mood.

In times of change there are bound to be fewer certainties and
more questions, frequently questions without easy answers. As
early as 1768 the painter Joseph Wright of Derby took as a sub-
ject a practical instance of contemporary ethics instead of an
antique theme. *Experiment with the Air Pump* shows the death of a
bird in the pump's evacuation chamber. The sacrifice of animal
life to the furtherance of science is acutely depicted in the sorrow
of the child whose pet is being destroyed, juxtaposed with the wis-
dom of the aged experimenter himself. Should humanity go forward
at the cost of destroying God's creation? Is animal life indeed the
creation of God? And have people a right to act as their own
arbiters in these matters? Such questions would not have arisen
if science had not opened up areas where moral certainties had
not previously had to be examined. The painting is classical in its

77

Joseph Wright,
*Experiment with the Air
Pump*, 1768, oil on
canvas, 184 × 244 cm,
The Tate Gallery,
London.

controlled paint surface, but the lighting is intense, creating a subjective rather than objective atmosphere, one where we must judge for ourselves the validity of the experiment.

There are no easy answers here, and the more men asked such questions the less easily did the answers come. The Christian religion, though formally accepted by most people in Europe, had not controlled the major aesthetic or critical debates in the course of the eighteenth century. Men took nature increasingly as the norm by which judgement should be made. But nature had many different guises. If nature became the guiding principle then surely every individual might become his own theologian and confessor, since each had an equal right to judge. Then again since the inequality of society was so glaring, should not something be done, forcibly, to create an egalitarian society? Revolutionary theories and practice flourished in this atmosphere. Similarly, such freedom of thought gave rise to a preoccupation with individuality, to an absorption in self, rather than in society as a whole. It is this preoccupation which is so typical of Romanticism,

78

the new movement that was to dominate the first part of the nineteenth century, in art, literature and music.

THE CONFLICT OF ROMANTICISM AND CLASSICISM

Few soldiers or statesmen have been so supported by the propaganda of art as Napoleon Bonaparte. While Napoleon himself may not have initiated it, he certainly helped consummate the cult of personality in all its romantic power. Of the many images of him none is so potent as David's *Napoleon crossing the Alps*. The painting is a masterpiece of classical technique and romantic emotion. This is no mere paradox. The development of classical theory took place throughout the eighteenth century in the minds of men who were all intensely subjective. Napoleon is seen urging on his armies in their passage through the Alps. It is an apparently hopeless journey, undertaken first in 218 BC by the Carthaginian general Hannibal. Just because it seems impossible, it is also a romantic journey, matching man against nature.

Napoleon's strained and sombre face reveals the dangers of the march. Behind the general's head rear the Alps, presenting to human endeavour the violent and relentless opposition of natural forces. This conflict is, for the artist and the sitter, a statement about the dignity of man and the grandeur of heroic determination. An ancient hero, Hannibal, is recalled in the French emperor's achievement. Napoleon took the cult of personality to its conclusion, crowning himself emperor with the victor's laurels, so that he should owe his power to no authority other than himself. In the triumphal processions of ancient Rome a man had been employed to stand at the shoulder of the victorious general reminding him that he was only human. Napoleon saw no need for such precautions. He was, in his own and his followers' eyes, another Mars, a god of war. In David's painting the god rides to inevitable victory.

The artist had learned what to depict by following rules governing the proportion and disposition of the human body. Men of taste recognised these rules, and judged a work by its adherence to them. But for us, one of the many fascinating aspects of the art

J. L. David, *Napoleon Crossing the Alps*, 1801, oil on canvas, 272 × 232 cm, Malmaison, Paris.

of the period is to discern how a tension builds up between the general rules, which apply to every work, and the artistic imagination. Where the individuality is most strongly marked in a work of art, where the artist expresses something important to himself, the dramatic tension between the ideal rule and individual's creation can tell us much about how these artists worked, and to what they most readily responded in their world.

Notes on artists

prepared by BARBARA *and* GEORGE BRENCHLEY

ADAM, ROBERT, born 1728 in Scotland, the second of four brothers (John, Robert, James and William) who all helped him in his career as an architect, James in particular as draughtsman and overseer. Robert matriculated at Edinburgh in 1743, left for France and Italy in 1754 and in Rome became friendly with Piranesi. In 1757 he took Clerisseau, an architectural draughtsman, and others with him to Spalato (Split) in Dalmatia, to study and make drawings of some of the buildings forming the ruins of Diocletian's Palace. The resultant folio of engravings, with a Preface by Robert, was published in 1764 and became an important element in the 'Adam Revolution'. Its significance lay in the choice of a *domestic* building for study, all Palladio's reconstructions from the antique having been based on temples and public buildings. Adam's own ideas, blended with and influenced by his classical studies, are clearly set out in this Preface and in several later volumes (*The Works in Architecture of R and J Adam*) where he claims to have brought about 'a greater movement and variety in the outside composition' of his buildings and 'an almost total change in the decoration of the inside'. It is above all this sense of movement which characterises his work. In a revival of Roman stucco decoration, and with delicate adaptation of classical motifs, he covers his walls with exquisitely executed stucco patterns in a light and quick rhythm. Though in architecture he most enjoyed working in the grand style (the ambitious Adelphi scheme in London, the Register House and the University of Edinburgh), his chief claim to fame is as a designer of moderate-sized houses (Kedleston, Syon House, 20 Portman Square – now the Courtauld Institute of Art), and of squares in Edinburgh and London which show town-planning ideas anticipating Nash. Though his rival Chambers managed to prevent his election to the Royal Academy, his style was widely imitated, and he is generally recognised as the father of the classical revival in Britain, with more buildings attributed to him than to any other British architect. He died in 1792.

BOUCHER, FRANCOIS, born Paris 1703. Early in his career he was employed in making engravings after many of Watteau's pictures. He won the Prix de Rome in 1723 but did not actually go to Italy until 1727. In Rome he was greatly influenced by Tiepolo. Unlike the Italian painter, however, he used the Rococo style not for heroic or religious subjects, but, after his return to France in 1731, specialised in mythological scenes, and in decorations based on pastoral plays such as Tasso's *Aminta*. Boucher was an extremely versatile artist: his decorative work ranged from colossal schemes for the royal palaces (Versailles, Fontainebleau, Marly) to designs for stage sets and fans. He became associated with, and made designs for, the Beauvais tapestry factory and eventually in 1755 was made director of the Gobelins manufactury. He painted imaginative landscapes and even some Chinese scenes when the fashion for Chinoiserie was at its height. About 1746 he became the favourite painter and friend of Madame de Pompadour, mistress of Louis XV, and his portraits of her are among his best works. Women, usually portrayed as Muses, nymphs or goddesses, play a dominant part in most of his designs and his facility in painting them was such that after his early days he usually dispensed with models altogether. He has been called the artist *par excellence* of the French Rococo. His was art designed for a sophisticated audience, an urban and courtly society. In 1765 he was appointed King's Painter, but by then tastes were changing with the advent of Neoclassicism. Boucher died in 1770.

CHAMBERS, SIR WILLIAM, born 1723 in Sweden of Scottish parents, educated in England. After some ten years spent travelling in the Far East in the service of the Swedish East India Company, and a year studying in Paris under the famous architectural teacher Blondel, he spent five years in Italy absorbing French and Italian influences before returning to England in 1755. He was appointed tutor in architecture to the Prince of Wales (later George III) and one of the two Architects of the Works (1760). The

second Architect, with whom he had to share an office, was Robert Adam, his principal rival, whose methods and ideas he detested, and whose election to the Royal Academy (of which Chambers himself was a founder-member) he managed to prevent. Two of his best-known designs are the Pagoda in Kew Gardens (the result of his early travels in China) and Somerset House, a vast building on the bank of the Thames made necessary by the expansion of the government services. Between 1759 and 1791 he published in several editions a statement of his academic principles (*Civil Architecture*), but perhaps his more important influence lay in his imposition, through the Royal Academy, of a code of professional conduct which led later, in the hands of Soane, to the creation of the Institute of British Architects. Died 1796.

CHARDIN, JEAN BAPTISTE SIMEON, born 1699 in Paris. His early work shows him adapting Dutch seventeenth-century pictures to suit French tastes, and their two main subjects – still-life and genre – continued to be his principal concern throughout his life. His genius lies in his exploration of the beauty of the commonplace: everyday objects, ordinary people doing ordinary things, but all transmuted by Chardin's sympathetic but quite unsentimental touch. The play of light on coloured surfaces is rendered by the use of an impasted technique (the brush heavily loaded with paint), while great depth of tone is achieved by delicacy of touch and the use of dragged and scumbled colour. Added to this is his strong sense of spacial order, so that the result is the creation in his pictures of an ideal world, though a very different one from Watteau's. Chardin's is a world of homely contentedness, with its beauty revealed by the eye and hand of a great artist. He was received into the Académie in 1728, became its Treasurer in 1755 and hung all its exhibitions for over 20 years. Fragonard was one of his pupils for a short time. Towards the end of his life his eyesight began to fail and he took to working in pastel. He died in Paris in 1779.

DAVID, JACQUES-LOUIS, born 1748 in France, studied under Vien. After winning the Prix de Rome in 1774 he spent the next seven years working in Rome, briefly visiting Paris where in 1782 he became a member of the Académie, and then, returning to Rome, began painting his famous *Oath of the Horatii*. This was perhaps the most important French Neo-classic picture and was intended by David to revive

and celebrate the austere virtues of early Rome, as a tribute to the past and an inspiration for the future. It was highly topical and immediately acclaimed in both Rome and Paris. During the Revolution he became a Deputy and voted for the death of Louis XVI, abolished the Académie and helped to found the Institut which took its place, was acknowledged as the painter of the Revolution and made memorial portraits of its martyrs (one, the *Death of Marat*, became a highly successful propaganda picture). After the fall of Robespierre he was imprisoned but later released, met and became an ardent supporter of Napoleon, and painted a series of pictures (1802–7) glorifying his exploits (e.g. *Napoleon Crossing the Alps*). After Waterloo and Bonaparte's fall he fled to Switzerland and eventually retired to Brussels. The later works show a change in technique and in feeling: cold colours and severe composition give place to a warmer palette and more movement, revealing a new response which has much in common with Romantic painting. He died in Brussels in 1825.

FRAGONARD, JEAN-HONORE, born 1732 at Grasse, was briefly (between 1750 and 1752) the pupil first of Chardin and then of Boucher. From 1756 to 1761 he was studying the works of Tiepolo in Rome and travelling, together with the architectural painter Hubert Robert, in Italy and Sicily, where he made many beautiful landscape drawings. In 1773 a tour in Holland and Belgium brought influences from Rubens and Rembrandt. He had an exceptional power of assimilating these various influences to produce a vivid and colourful style of his own. Lancret (1690–1743) and Pater (1695–1736) had painted *fêtes galantes* very much in the style of Watteau but without his special sensibility. Fragonard also often chose similar subjects but by his treatment of them he succeeded in infusing new life into the Rococo style, of which he was the last and one of the greatest exponents. In 1771 Madame du Barry commissioned a series of decorations from him, but the work was fianlly given to one of the Neoclassic painters, Vien. In the end Fragonard supported the Revolution, becoming Conservateur des Musées. He died in 1806.

GABRIEL, ANGE-JACQUES, born 1698 in France the son of an architect, engineer and town-planner, was a facile draughtsman and designer. He was appointed Contrôleur de Versailles in 1734, First

Architect to the King in 1742, designed many public buildings – the Opéra of Versailles, the Ecole Militaire (1751), the Place de la Concorde (1754) – and carried out several important projects at the Louvre and at Fontainebleau. But perhaps his most famous work was the Petit Trianon in the gardens of Versailles, designed for Madame de Pompadour, though she did not live to inhabit it. The house is a handsome small cube, with no curved projections or pediments but with exquisite stone masonry and a very few, restrained, external enrichments. It has been called the most purely 'Attic' gem of French architecture. Gabriel, never having been in Italy, formed his mature style by means of a study of the most classical French architects of the seventeenth century. He was himself the last and one of the most sensitive working in the French classical tradition. He died in 1782.

GAINSBOROUGH, THOMAS, born 1727 at Sudbury, Suffolk, showed skill in drawing very early and at the age of only 13 was sent to London, where he studied French engravings under Gravelot before leaving for the studio of Hayman, who was then teaching painting at the St Martins Lane Academy. Here Gainsborough was in a world of engravers, draughtsmen and illustrators where he clearly enjoyed himself and where he met Hogarth, who was very interested in the boy. But in 1748, married yet still only 21, he returned to Suffolk, where he painted landscapes (e.g. *Cornard Wood*) somewhat in the style of seventeenth-century Dutch masters, as well as many portraits of local people. These sitters were often his middle-class friends but they also included local landowners (like Mr and Mrs Andrews) seen in their parks – typical East Anglian farmlands, though slightly idealised. These pictures can be regarded as very anglicised versions of French Rococo landscapes, while their compositions are sometimes very similar to those used by Watteau. Gainsborough was in fact a great admirer of Watteau and resembled him in his passion for music: musical instruments quite frequently occur in the pictures of both men. In 1759 Gainsborough moved to Bath, where he began to paint society portraits and finally, in 1774, to London again. Here he became fashionable and the royal family's favourite painter. He had learnt much from the portraits of Rubens and van Dyck and this, with his natural sense of style, his eye for character and his sheer painting ability, make him the greatest British portrait painter. In spite of his

admiration for Watteau it was only quite late in life that he attempted what was then called a 'fancy picture', but one such painting – his *Musidora Bathing* – shows how close he was to the French Rococo spirit. He is, indeed, the only important British painter to whom the word Rococo could reasonably be applied. In 1768 he was elected a founder-member of the Royal Academy. Died 1788.

HOGARTH, WILLIAM, born 1697 in London, started his artistic career at the age of 18 as apprentice to an engraver of silver plates in the Rococo tradition. He became an excellent portrait painter and also painted small groups and conversation pieces, including a scene from *The Beggars' Opera*. This play satirised the currently popular Rococo operas and pointed the way towards Hogarth's series of moralities exposing other topical features of eighteenth-century London life, with titles such as *Marriage à la Mode*, *The Rake's Progress* and *The Harlot's Progress*. Hogarth intended that each painting should represent a scene in a play. This theatrical association and the pictures and furniture depicted provide links with French Rococo painters, but whereas the French scenes are pastoral, Hogarth's are urban; the French are celebrations of gaiety, Hogarth's are studies in degradation, though his object in painting them is a moral one – something which art had not had since the middle ages. The morals inculcated here, however, are more concerned with bourgeois standards than with religious excellence. It is of interest that Hogarth was violently anti-French in his attitude, an attitude not improved by his being taken for an English spy at Calais on his return journey after a visit to Paris in 1748. It is in keeping with his moral intentions that Hogarth's fame rests not on his original paintings but on the hundreds of engravings of them that were soon in circulation. In 1753 he wrote and published a largely original work called *The Analysis of Beauty*, of which Horace Walpole said that it contained many sensible points and observations though it 'did not carry the conviction nor meet the acquiescence that its author had expected'. On the whole, literary critics were kind, but – as might be expected – practising artists were not in favour of this attempt to provide them with rules. Hogarth died in London in 1764.

MENGS, ANTON RAPHAEL, born 1720, the son of a Dresden court painter. He was brought

up to paint in the manner of Correggio and Raphael, and he himself became court painter at Dresden in 1745. In 1755 he met Winckelmann, the first German art historian and one of the early protagonists of the Neoclassical style which was then coming into favour. This style was partly a move towards truth to nature as a reaction from the artificialities of the Rococo and partly a return to the antique for a model – a movement stimulated by the excavations then being carried out at Pompeii and Herculaneum. Mengs was working in Rome in 1757 but his paintings of that period are not markedly Neoclassic in style. Only a few years later, however, also in Rome, he painted his most famous picture, *Parnassus* – a ceiling decoration in the Villa Albani (1761). This shows a complete break with the steep perspective ceilings of the Rococo; it is painted as if it were to be seen at eye level. In 1762 Mengs published a treatise on beauty in painting, attempting to codify the requirements for producing great art. It involved an erroneous belief that classical art was the product of a calm and ordered society and that truth itself should be a rationalised truth of *essence*, its expression not hindered by irrelevant detail, however natural in themselves such details might be. The key to the production of true beauty was thus seen to be the representation of simplified forms of nature in classical surroundings – a view which became almost a new creed. Unfortunately Mengs' own paintings were characterised by a lack of imagination and a very poor sense of colour, but the influence of his writings in the mid-eighteenth century was considerable. He spent much of the later part of his life in Spain, where altarpieces that he had painted for the church of S. Pascal at Aranjuez were preferred to those submitted by Tiepolo. He died in Rome in 1779.

NASH, JOHN, born 1752, practised at first in Wales, but some of his most influential work was done in England after 1806 (when he became architect to the Office of Woods and Forests), and even more after 1815 (when he was appointed to the Board of Works) and thus lies outside the limit of the eighteenth century. However, he is both interesting and a significant figure in a transitional period, first through the hamlet he set in the grounds of Blaize Castle near Bristol and the buildings he placed in and around Regent's Park (1811–25), which act as a link between the picturesque of the true eighteenth century and the Garden City ideas of the twentieth, and second, as an example of what has been called the 'fancy-dress ball of architecture' of the nineteenth century, in his willingness to design in a variety of styles – Classical, Gothic, Italianate, old-English cottage and even (in the Brighton Pavilion) a mixture of several Oriental styles – according to the demands of the individual site and occasion. Working closely with the landscape gardener Humphry Repton he became a master of the scenic use of the classical idiom, and left a strong imprint on London through the brilliant town-planning schemes he carried out (1821–32) for George IV, for whom also he designed Buckingham Palace and the Marble Arch which originally stood at its entrance. His favourite material was stucco, which he used with a light hand. Both socially and professionally he was highly successful, and built for his own occupation a Gothic mansion, East Cowes Castle, in the Isle of Wight. He died in 1835.

NEUMANN, BALTHASAR, born 1657. Unlike the other builders of German Baroque/Rococo (the distinction between the two descriptions is often difficult to make) Neumann started his career as an engineer, designing town plans and fortifications. He became court architect to the Bishop of Würzburg and in 1725 was sent to Nancy and Paris to study contemporary French architecture, especially the Rococo town houses built in a miniature version of the dynamic Baroque style of Borromini. On his return to Germany he designed the great staircase and the Kaisersaal of the Bishop's Palace at Würzburg. These are probably the greatest achievements of secular Baroque in Germany, and Neumann was exceptionally fortunate in that the ceilings in both were decorated by G. B. Tiepolo, the master of Rococo decoration. Here the architect and the decorator have achieved the unification of the real and the fictitious worlds. In S. Germany there are many so-called pilgrimage churches, the finest of all being the one built by Neumann and dedicated to the *Vierzehnheiligen* (the Fourteen Saints). The first impression on entering this church is one of bliss and elevation – it is all light tones, white, gold and pink. Later comes the realisation of a highly skilled organisation of space. In fact the church is a series of intersecting ovals, their relationships worked out like an intricate mathematical problem with the eye being eventually led to the high altar. The whole effect is somewhat theatrical and makes it difficult to see where the worldly ends and the spiritual begins.

The building and decoration of the church took from 1740 to 1752, and Neumann died in 1753.

PIRANESI, GIOVANNI BATTISTA, born 1720 in Venice, the son of a stonemason. He was trained as an architect, but showed such amazing skill in drawing architecture that in 1740 he was chosen to accompany the new Venetian ambassador to Rome, where for thirty years he drew and etched both the classical and modern buildings of the city. His etchings of the many churches and palaces built in the seventeenth century are comparatively commonplace, but he found the true Roman remains terrifying and oppressive. In his etchings of them human beings are reduced to insignificance by gigantic and incomprehensible buildings, which seemed to him not the former settings for a serene social life, as they had appeared to the Neoclassical theorists, but prisons. He had a unique power of combining solidity with a detailed reproduction of the surface of stone, made extremely dramatic by his use of light and shade. These etchings, a series of 137 begun in 1745 and known as the *Vedute*, had a wide circulation throughout Europe and went far to establish the late-eighteenth-century view of the power and might of Rome. While producing the *Vedute* Piranesi was creating an even more imaginative series of etchings, the *Carceri d'Invenzione*, nightmarish visions of prison interiors with menacing galleries which end amid vague threats of torture and despair. These were re-worked in 1761 and fascinated the men of the late eighteenth century, to whom the Lisbon earthquake of 1755 had, in Goethe's phrase, 'released the Demon of Fear'. The calm optimism of the so-called Age of Reason was breaking down. His etchings continued to be printed long after Piranesi's death in 1778.

REYNOLDS, SIR JOSHUA, born 1723 at Plympton in Devon, where his father was headmaster of the Grammar School; he was therefore brought up in an atmosphere of learning. After three years studying in London and six as an independent portrait painter in his native Devon he went in 1749 to Italy, and in Rome made an intensive study of the antique, particularly of Raphael, Michelangelo, Correggio and Titian, before returning to England where, in 1753, he settled in London. He rapidly made a name for himself, moving in cultivated circles which included Dr Johnson, Garrick and Goldsmith. When the Royal Academy was founded in 1768 he was the obvious choice for its first President; he was knighted the next year and made D.C.L. at Oxford (an honour which would have been unthinkable for a painter only one generation earlier). Between 1781 and 1789 he visited Holland and Flanders, where he was profoundly influenced by Rubens' handling of paint. As President of the R.A. he delivered a series of fifteen *Discourses* which have become the classical exposition of the doctrine of the Grand Manner and embody his views on the function and purpose of art. There are two basic ideas: the first is that art should imitate nature – but a universal nature, the ideal type, not the particular ('to paint particulars is not to paint nature, it is only to paint circumstances'); the second is that the object of art is ethical improvement. For him, taste was not a matter of sensibility but 'the power of distinguishing right and wrong' in the arts, and the most important requisite for forming a 'just taste' was to 'have recourse to reason and philosophy'. His own work did not always illustrate his theories, for he had a genuine creative gift. The overwhelming majority of his pictures are portraits: almost every man and woman of note in the second half of the century was painted by him. Because of defective technical procedures many of his pictures cracked and faded even in his own lifetime. He died in 1792.

SOUFFLOT, JACQUES-GERMAIN, born 1713 in France, the most important architect of the generation after Gabriel's. After several journeys to Rome as the protégé of Madame de Pompadour's brother, the Surintendant des Bâtiments, he acquired a taste for the antique, both classical and Gothic, and in 1750 went to see the temples of Paestum. He had already made a name for himself through his lectures and in 1762 declared that one ought to combine the Greek orders with 'the lightness which one admires in some Gothic buildings'. In his most important commission, the building of the church of Ste Geneviève, re-named the Panthéon during the Revolution and designed to be used as a burial place for distinguished citizens, he had the chance to put this belief into practice. The design of the church was revolutionary for France, though Soufflot clearly was familiar with Wren's St Paul's: the plan consists of a detached Greek cross, with a splendid dome on a high colonnaded drum rising above the crossing, and with lower domes covering the four arms, all carried on columns with straight entablatures. The combination of strict regularity and Roman detail

with the lightness of the slim piers and columns is Soufflot's most original contribution (corresponding closely to what Robert Adam was trying to do in England). A contemporary devotee of the new classicism hailed the Panthéon as 'le premier modèle de la parfaite architecture'. Soufflot died in 1780.

TIEPOLO, GIOVANNI BATTISTA (GIAMBATTISTA), born 1696, the most brilliant and influential Italian Rococo painter. His fame rests mainly on his frescoes. At first these were in the relatively dark manner of Piazetta, but later he developed the clear, sunny palette characteristic of most of his works. For ceilings this was combined with the use of very steep perspectives so that the viewer seems to be looking up into infinite space. After frescoes at Udine (1726) and other Italian cities he was invited to Würzburg to decorate the palace of the Prince-Bishop, in particular the ceilings of the Kaisersaal and the grand staircase (1750–53). The palace is one of the supreme examples of German Rococo architecture and it provided the perfect setting for magnificent Tiepolo ceilings. That of the Kaisersaal shows, in a vast airy allegory, Tiepolo's patron the Bishop apparently officiating at the twelfth-century marriage of the Emperor Frederic Barbarossa to Beatrice of Burgundy; the colour scheme is the typical Rococo white, gold and pastel and the ceiling leads the eye soaring up into a limitless blue sky flecked with sunlit cloud. The whole seems entirely weightless, and the effect on the viewer is exhilarating. This visual linking of earth and heaven enables Tiepolo to illustrate miracles such as the descent of the Virgin Mary to come to the help of a saint (in the Scuola dei Carmini, Venice), where the miraculous nature of the event is most brilliantly displayed. In general, however, Tiepolo's vivid imagination is more suited to secular subjects (such as the scenes from the life of Cleopatra in the Gran Salone in Venice (1750), and the Barbarossa marriage in Würzburg) in which great events are made to seem even greater. In 1762 Tiepolo was called to Madrid to decorate the Royal Palace, in particular the ceiling of the throne room. But by then tastes were changing, and the seven altarpieces which he painted for the church of S. Pascal at Aranjuez were rejected in favour of a series by Mengs. Tiepolo never returned to his native Italy; he died in Madrid in 1770.

WATTEAU, (JEAN) ANTOINE, born 1684 at Valenciennes, went to Paris in 1702 as assistant to Gillot, a painter of theatrical scenes. In 1707 he had access to the Rubens series of paintings in the Luxembourg depicting the life of Marie de' Medici, and was deeply impressed and influenced by his study of them. In 1712 he was made Agréé of the Académie and should then have submitted a Diploma work, but he delayed this until 1717 when, quite exceptionally, the Académie allowed him to choose his own subject. The work he submitted was Embarkation for Cythera, a painting which did not fit into any of the regular categories, so a special one – the fête galante – was instituted to accommodate its reception. The subject of the picture is based on the Rubens Garden of Love but its atmosphere, like that of most of Watteau's paintings, is something unique and dreamlike. In a typical Watteau fête galante the figures, mostly derived from drawings in his famous sketch books, are intensely real. Music is in the air and the scene is one of apparent gaiety. But the gaiety hides a deep sense of melancholy – that the music must come to an end, the dream fade. The sense of impending loss has sharpened the love for what is soon to vanish. His last painting was a signboard (l'Enseigne) for the art shop of his friend Gersaint, which showed the interior of the shop with its customers and shop assistants. In spite of the complete change of environment, something of the atmosphere of the fêtes remains. The realistic subject emphasises that Watteau, although he employs many of the trappings of the Rococo style, is yet somewhat apart, and in the Enseigne his exploration of the beauty of ordinary things and people has much in common with the genre painting of Chardin. He died in 1721.

ZOFFANY, JOHANN, born 1734/5 at Frankfurt-am-Main and studied at Ratisbon. After travelling for some years in Austria and Italy he worked mainly in England, where (about 1758) he first found employment as a decorator of clock-faces. In 1770 he returned to Italy with a commission from Queen Charlotte to paint the Tribuna of the Uffizi Gallery (now at Windsor Castle). His main work consists of portraits, conversation pieces and theatrical scenes, many of these last including portraits of Garrick in various roles; these brought him immediate success. His conversation pieces are crowded with figures and lively in spirit, the skill with which details of feature and costume are painted making them valuable as records for historians of the period, though their artistic merit may not be considered very high. Zoffany died in 1810.

Glossary

ACADEMY institution in which the study of the arts or sciences is carried on. Academic art is therefore art relying on the support of a course of training in drawing and painting to a high degree of finish.

ACANTHUS a plant with deeply serrated prickly leaves.

ARCADE range of arches, carrying a roof, supported by columns.

ARCHITRAVE the lowest member of an entablature – the beam that spans the tops of adjacent columns.

BAROQUE the name given to the style of art and architecture originating in Italy but dominant in Europe throughout the seventeenth century. Characterised by the violence of its movement and dramatic impact.

BASILICA in ancient Rome, a large meeting hall, usually rectangular; in Early Christian times, a church, since the early church adopted essentially the earlier meeting-hall type of building for most new structures; hence used still to refer to the original churches of early Christian Rome and elsewhere.

CAPITAL the head or crowning feature of a column or pilaster.

COMPOSITION the grouping of figures and other elements in a canvas.

CORINTHIAN the fourth classical order; columns are deeply fluted and have capitals shaped as inverted bells with acanthus leaf decoration.

DILETTANTE literally an amateur. In eighteenth-century usage the term denoted expertise in the fine arts. The modern critical meaning was then a secondary one.

DORIC the first classical order; columns are broader than in other orders, have broad shallow flutes, no base, and saucer-shaped capitals.

ENTABLATURE the complete set of horizontal members resting on top of a column and running continuously above a colonnade; usually consists of architrave, frieze, and cornice.

FACADE the facing of a building, used to describe the architectural elements and their organisation on the wall surface.

FÊTE CHAMPÊTRE (or *fête galante*) literally a graceful or noble party. Generally used to describe the category of evocative figure group in park-like setting produced by Watteau and his school.

FINIAL the bunch of foliage etc. on the top of a pinnacle, spire, gable etc.

FOLIO a large book size. The size of volume which was generally used for artistic, architectural or archaeological books in the eighteenth century.

FOLLY a building without purpose, hence a foolish exercise; usually an ornamental building erected to decorate a park or garden.

GROTTO stone built folly, or adapted cave, generally intended to give a rough and natural appearance; the setting usually for a hermit or monkish figure.

HANDLING the manner in which the artist applies paint to the canvas.

IMPASTO artistic term for the sculptural effect achieved by applying thick paint to the canvas in broad deep strokes.

MAUSOLEUM memorial building erected to contain a tomb or commemorate the dead. The first mausoleum was built for King Mausolus and was one of the seven wonders of the ancient world.

MUSE any of the nine sister goddesses of the liberal arts, daughters of Zeus.

NEOCLASSICAL the prefix denotes the consciously historical or revivalist approach to classical architecture; a strict academic style in art.

NICHE small recess in wall.

ORDER in classical architecture, a column together with its base (if any) and capital, and including also the entablature; the five principal orders (Doric, Tuscan, Ionic, Corinthian, and composite) follow traditional patterns.

PALETTE literally the wooden panel on which the artist's colours are mixed. Used technically to describe the range of colour an artist employs.

PANTHEON a gathering of the finest or noblest people or objects. Hence a building commemorating national heroes, or a gallery of admired works of art.

PORTICO columned porch before the entrance to a building.

ROCOCO thought to derive from the French word *rocaille*, meaning rock-work. Used to define the elaborate fragile and ornamental style of art and architecture popular in Europe in the first half of the eighteenth century.

STUCCO plaster used in Rococo decoration to create elaborate patterns, but also used externally on houses built of brick to give the impression of stone work.

Further reading

GENERAL READING

Clark, K. *Civilisation*, BBC and John Murray 1969
Gombrich, E. H. *The Story of Art*, Phaidon 1954
Janson, H. W. *History of Art*, Prentice-Hall 1974
Pevsner, N. *Outline of European Architecture*, Penguin 1973

FURTHER READING ON THE PERIOD

Adams, W. H. *The French Garden 1500–1800*, Scolar Press 1979
Arts Council. *The Age of NeoClassicism* (exhibition catalogue) 1972
Clark, K. *Romantic Rebellion*, John Murray 1973
Crook, J. M. *The Greek Revival*, John Murray 1972
Dixon Hunt, J. and Willis, P. (ed.) *The Genius of the Place: the English Landscape Garden 1620–1820*, Elek 1975
Hitchcock, H. R. *Rococo Architecture in Southern Germany*, Phaidon 1968
Honour, H. *Chinoiserie*, John Murray 1961
Kalnein, W. G. and Levey, M. *Art and Architecture of the Eighteenth Century in France*, Penguin 1972
Summerson, J. *Architecture in Britain 1530–1830*, Penguin 1953
Wilton-Ely, J. *The Mind and Art of Giovanni Battista Piranesi*, Thames and Hudson 1978

Index

Page references of illustrations are indicated by bold type